Tom Wolfe grew up in Richmond, Virginia, and graduated from Washinton and Lee University. He received his doctorate in American Studies from Yale University. Mr Wolfe worked as a reporter for the *Springfield Union* (Massachusetts), *The Washington Post,* and the New York *Herald Tribune.* His writing has also appeared in *New York* magazine, *Esquire*, and *Harper's.*

The Kandy-Kolored Tangerine-Flake Streamline Baby was published in 1965, and in 1968 *The Pump House Gang* and *The Electric Kool-Aid Acid Test* were published simultaneously. *Radical Chic and Mau-Mauing the Flak Catchers,* a devastatingly funny portrayal of political stances and social styles in our status-minded world, was published in 1970.

In 1975, *The Painted Word*, an incandescent, hilarious look at the world of modern art, was published; it caused as much controversy as anything Mr Wolfe had written. *The Painted Word* received a special citation from the National Sculpture Society, the oldest and largest organization of professional sculptors in the United States. *Mauve Gloves and Madmen, Clutter and Vine,* a collection of essays, was published in 1976.

The Right Stuff, which was published in 1979, won the American Book Award for general nonfiction. The American Academy and Institute of Arts and Letters named Mr Wolfe as recipient of the Harold D. Vursell Memorial Award for 1980. In the same year, he received the Columbia Journalism Award for distinguished service to the field of journalism. *From Bauhaus to Our House*, his distinctive look at contemporary architecture, was published in 1981. In 1982, *The Purple Decades, A Reader*, was published.

Tom Wolfe's first novel, *The Bonfire of the Vanities*, was published in 1987.

Tom Wolfe lives in New York Ci

Author photograph by Tom Vic

D0351221

Also by Tom Wolfe

THE RIGHT STUFF
THE ELECTRIC KOOL-AID ACID TEST
THE PUMP HOUSE GANG

and published by Black Swan

Tom Wolfe

THE PAINTED WORD

BLACK SWAN

THE PAINTED WORD
A BLACK SWAN BOOK 0 552 99370 0

Originally published in Great Britain by
Bantam Books.

PRINTING HISTORY
Bantam edition published 1976
Black Swan edition published 1989

Published entirely by HARPER'S MAGAZINE April 1975
Excerpts appeared in the WASHINGTON STAR NEWS June 1975
and in the BOOK DIGEST September 1975

Black Swan Books are published by Transworld Publishers
Ltd., 61–63 Uxbridge Road, Ealing, London W5 5SA, in
Australia by Transworld Publishers (Australia) Pty. Ltd.,
15 – 23 Helles Avenue, Moorebank, NSW 2170, and in
New Zealand by Transworld Publishers (N.Z.) Ltd.,
Cnr. Moselle and Waipareira Avenues, Henderson,
Auckland.

Made and printed in Great Britain by
The Guernsey Press Ltd., Guernsey, Channel Islands.

THE PAINTED WORD

People don't read the morning newspaper, Marshall McLuhan once said, they slip into it like a warm bath. Too true, Marshall! Imagine being in New York City on the morning of Sunday, April 28, 1974, like I was, slipping into that great public bath, that vat, that spa, that regional physiotherapy tank, that White Sulphur Springs, that Marienbad, that Ganges, that River Jordan for a million souls which is the Sunday *New York Times*. Soon I was submerged, weightless, suspended in the tepid depths of the thing, in Arts & Leisure, Section 2, page 19, in a state of perfect sensory deprivation, when all at once an extraordinary thing happened:

I *noticed something!*

Yet another clam-broth-colored current had begun to roll over me, as warm and predictable as

3

the Gulf Stream . . . a review, it was, by the *Times*'s
dean of the arts, Hilton Kramer, of an exhibition at
Yale University of "Seven Realists," seven realistic
painters . . . when I was *jerked alert* by the fol-
lowing:

"Realism does not lack its partisans, but it does
rather conspicuously lack a persuasive theory. And
given the nature of our intellectual commerce with
works of art, to lack a persuasive theory is to lack
something crucial—the means by which our ex-
perience of individual works is joined to our under-
standing of the values they signify."

Now, you may say, My God, man! You woke up
over *that*? You forsook your blissful coma over a
mere swell in the sea of words?

But I knew what I was looking at. I realized that
without making the slightest effort I had come
upon one of those utterances in search of which
psychoanalysts and State Department monitors of
the Moscow or Belgrade press are willing to endure
a lifetime of tedium: namely, the seemingly in-
nocuous *obiter dicta,* the words in passing, that
give the game away.

What I saw before me was the critic-in-chief of
The New York Times saying: In looking at a paint-
ing today, "to lack a persuasive theory is to lack
something crucial." I read it again. It didn't say
"something helpful" or "enriching" or even "ex-
tremely valuable." No, the word was *crucial*.

In short: frankly, these days, without a theory to
go with it, I can't *see* a painting.

Then and there I experienced a flash known as

the *Aha!* phenomenon, and the buried life of contemporary art was revealed to me for the first time. The fogs lifted! The clouds passed! The motes, scales, conjunctival bloodshots, and Murine agonies fell away!

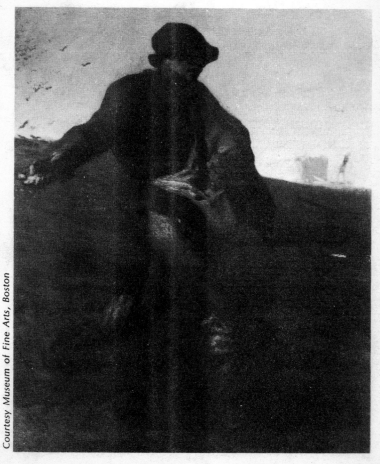

Courtesy Museum of Fine Arts, Boston

Jean François Millet, *The Sower* (1850–51).
At the time Millet was considered something of a rip,
because he painted such Low Rent folk. Only later
was this called "literary" or "narrative" art

5

THE PAINTED WORD

All these years, along with countless kindred souls, I am certain, I had made my way into the galleries of Upper Madison and Lower Soho and the Art Gildo Midway of Fifty-seventh Street, and into the museums, into the Modern, the Whitney, and the Guggenheim, the Bastard Bauhaus, the New Brutalist, and the Fountainhead Baroque, into the lowliest storefront churches and grandest Robber Baronial temples of Modernism. All these years I, like so many others, had stood in front of a thousand, two thousand, God-knows-how-many thousand Pollocks, de Koonings, Newmans, Nolands, Rothkos, Rauschenbergs, Judds, Johnses, Olitskis, Louises, Stills, Franz Klines, Frankenthalers, Kellys, and Frank Stellas, now squinting, now popping the eye sockets open, now drawing back, now moving closer—waiting, waiting, forever waiting for . . . *it* . . . for *it* to come into focus, namely, the visual reward (for so much effort) which must be there, which everyone (*tout le monde*) knew to be there —waiting for something to radiate directly from the paintings on these invariably pure white walls, in this room, in this moment, into my own optic chiasma. All these years, in short, I had assumed that in art, if nowhere else, seeing is believing. Well —how very shortsighted! Now, at last, on April 28, 1974, I could *see*. I had gotten it backward all along. Not "seeing is believing," you ninny, but "believing is seeing," for *Modern Art has become completely literary: the paintings and other works exist only to illustrate the text.*

Like most sudden revelations, this one left me dizzy. How could such a thing be? How could Modern Art be *literary*? As every art-history student is told, the Modern movement began about 1900 with a complete rejection of the *literary* nature of academic art, meaning the sort of realistic art which originated in the Renaissance and which the various national academies still held up as the last word.

Literary became a code word for all that seemed hopelessly retrograde about realistic art. It probably referred originally to the way nineteenth-century painters liked to paint scenes straight from literature, such as Sir John Everett Millais's rendition of Hamlet's intended, *Ophelia*, floating dead (on her back) with a bouquet of wildflowers in her death grip. In time, *literary* came to refer to realistic painting in general. The idea was that half the power of a realistic painting comes not from the artist but from the sentiments the viewer hauls along to it, like so much mental baggage. According to this theory, the museum-going public's love of, say, Jean François Millet's *The Sower* has little to do with Millet's talent and everything to do with people's sentimental notions about The Sturdy Yeoman. They make up a little story about him.

What was the opposite of literary painting? Why, *l'art pour l'art*, form for the sake of form, color for the sake of color. In Europe before 1914, artists invented Modern styles with fanatic energy

THE PAINTED WORD

—Fauvism, Futurism, Cubism, Expressionism,
Orphism, Supermatism, Vorticism—but everybody
shared the same premise: henceforth, one doesn't

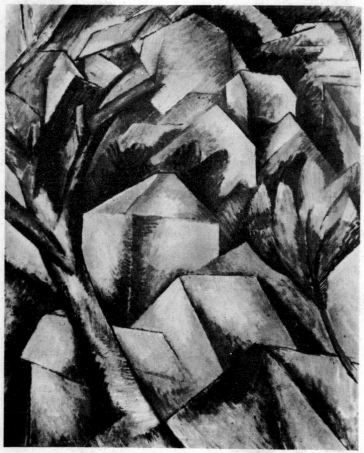

Museum of Fine Arts, Bern, the Hermann and Margrit Rupf Collection

Georges Braque, *Houses* at *l'Estaque* (1908).
But not really houses, said Braque; rather, a certain
arrangement of colors and forms on a canvas.
("Little cubes," said Matisse to the critic Louis Vauxcelles,
who called Braque's new style "Cubism,"
thinking it a prize put-down.) The *Theory* starts here

paint "*about* anything, my dear aunt," to borrow a line from a famous *Punch* cartoon. One just *paints*. Art should no longer be a mirror held up to man or nature. A painting should compel the viewer to see it for what it is: a certain arrangement of colors and forms on a canvas.

Artists pitched in to help make theory. They loved it, in fact. Georges Braque, the painter for whose work the word *Cubism* was coined, was a great formulator of precepts:

"The painter thinks in forms and colors. The aim is not to *reconstitute* an anecdotal fact but to *constitute* a pictorial fact."

Today this notion, this protest—which it was when Braque said it—has become a piece of orthodoxy. Artists repeat it endlessly, with conviction. As the Minimal Art movement came into its own in 1966, Frank Stella was saying it again:

"My painting is based on the fact that only what can be seen there *is* there. It really is an object . . . What you see is what you see."

Such emphasis, such certainty! What a head of steam—what patriotism an idea can build up in three-quarters of a century! In any event, so began Modern Art and so began the modern art of Art Theory. Braque, like Frank Stella, loved theory; but for Braque, who was a Montmartre **boho***** of the primitive sort, art came first. You can be sure the poor fellow never dreamed that during his own lifetime that order would be reversed.

***** Twentieth-century American slang for *bohemian;* obverse of *hobo.*

1

The apache dance

Hot off the Carey airport bus, looking for lofts

All the major Modern movements except for De Stijl, Dada, Constructivism, and Surrealism began before the First World War, and yet they all *seem* to come out of the 1920s. Why? Because it was in the 1920s that Modern Art achieved social chic in Paris, London, Berlin, and New York. Smart people talked about it, wrote about it, enthused over it, and borrowed from it. Borrowed from it, as I say; Modern Art achieved the ultimate social acceptance: interior decorators did knock-offs of it in Belgravia and the sixteenth arrondissement.

Things like knock-off specialists, money, publicity, the smart set, and Le Chic shouldn't count in the history of art, as we all know—but, thanks to the artists themselves, they do. Art and fashion

are a two-backed beast today; the artists can yell at fashion, but they can't move out ahead. That has come about as follows:

By 1900 the artist's arena—the place where he seeks honor, glory, ease, Success—had shifted twice. In seventeenth-century Europe the artist was literally, and also psychologically, the house guest of the nobility and the royal court (except in Holland); fine art and court art were one and the same. In the eighteenth century the scene shifted to the *salons,* in the homes of the wealthy bourgeoisie as well as those of aristocrats, where Culture-minded members of the upper classes held regular meetings with selected artists and writers. The artist was still the Gentleman, not yet the Genius. After the French Revolution, artists began to leave the *salons* and join *cénacles,* which were fraternities of like-minded souls huddled at some place like the Café Guerbois rather than a town house; around some romantic figure, an artist rather than a socialite, someone like Victor Hugo, Charles Nodier, Théophile Gautier, or, later, Edouard Manet. What held the *cénacles* together was that merry battle spirit we have all come to know and love: *épatez la bourgeoisie,* shock the middle class. With Gautier's *cénacle* especially . . . with Gautier's own red vests, black scarves, crazy hats, outrageous pronouncements, huge thirsts, and ravenous groin . . . the modern picture of The Artist began to form: the poor but free spirit, plebeian but aspiring only to be classless, to cut himself forever free from the bonds of the

greedy and hypocritical bourgeoisie, to be what-
ever the fat burghers feared most, to cross the
line wherever they drew it, to look at the world
in a way they couldn't *see,* to be high, live low,
stay young forever—in short, to be the bohemian.

By 1900 and the era of Picasso, Braque & Co.,
the modern game of Success in Art was pretty
well set. As a painter or sculptor the artist would
do work that baffled or subverted the cozy bour-
geois vision of reality. As an individual—well, that
was a bit more complex. As a bohemian, the artist
had now left the *salons* of the upper classes—
but he had not left their world. For getting away
from the bourgeoisie there's nothing like packing
up your paints and easel and heading for Tahiti,
or even Brittany, which was Gauguin's first stop.
But who else even got as far as Brittany? Nobody.
The rest got no farther than the heights of Mont-
martre and Montparnasse, which are what?—per-
haps two miles from the Champs Elysées. Likewise
in the United States: believe me, you can get all
the tubes of Winsor & Newton paint you want in
Cincinnati, but the artists keep migrating to New
York all the same You can see them six days
a week . . . hot off the Carey airport bus, lined
up in front of the real-estate office on Broome
Street in their identical blue jeans, gum boots, and
quilted Long March jackets . . . looking, of course,
for the inevitable Loft . . .

No, somehow the artist wanted to remain within
walking distance . . . He took up quarters just
around the corner from . . . *le monde,* the social

15

Ronald Searle, *La Vie de Bohème*

sphere described so well by Balzac, the milieu
of those who find it important to be *in fashion,*
the orbit of those aristocrats, wealthy bourgeois,
publishers, writers, journalists, impresarios, per-
formers, who wish to be "where things happen,"
the glamorous but small world of that creation of
the nineteenth-century metropolis, *tout le monde,*
Everybody, as in "Everybody says" . . . the smart
set, in a phrase . . . "smart," with its overtones of
cultivation as well as cynicism.

The ambitious artist, the artist who wanted Suc-
cess, now had to do a bit of psychological double-

tracking. Consciously he had to dedicate himself
to the antibourgeois values of the *cénacles* of
whatever sort, to bohemia, to the Bloomsbury
life, the Left Bank life, the Lower Broadway Loft
life, to the sacred squalor of it all, to the grim
silhouette of the black Reo rig Lower Manhattan
truck-route internal-combustion granules that
were already standing an eighth of an inch thick
on the poisoned roach carcasses atop the electric
hot-plate burner by the time you got up for break-
fast . . . Not only that, he had to dedicate himself
to the quirky god Avant-Garde. He had to keep
one devout eye peeled for the new edge on the
blade of the wedge of the head on the latest pick
thrust of the newest exploratory probe of this fall's
avant-garde Breakthrough of the Century . . . all
this in order to make it, to be noticed, to be
counted, within the community of artists them-
selves. What is more, he had to be *sincere* about
it. At the same time he had to keep his other eye
cocked to see if anyone in *le monde* was watch-
ing. *Have they noticed me yet?* Have they even
noticed *the new style* (that me and my friends are
working in)? Don't they even *know* about Tension-
ism (or Slice Art or Niho or Innerism or Dimen-
sional Creamo or whatever)? (Hello, out there!)
. . . because as every artist knew in his heart of
hearts, no matter how many times he tried to
close his eyes and pretend otherwise (*History!
History!—where is thy salve?*), Success was *real*
only when it was success within *le monde*.

He could close his eyes and try to believe that all that mattered was that *he* knew his work was great . . . and that other artists respected it . . . and that History would surely record his achievements . . . but deep down he knew he was lying to himself. *I want to be a Name, goddamn it!*—at least that, a name, a name on the lips of the museum curators, gallery owners, collectors, patrons, board members, committee members, Culture hostesses, and their attendant intellectuals and journalists and their *Time* and *Newsweek*—all right!—even that!—*Time* and *Newsweek*—Oh yes! (ask the shades of Jackson Pollock and Mark Rothko!)—even the goddamned journalists!

During the 1960s this entire process by which *le monde,* the culturati, scout bohemia and tap the young artist for Success was acted out in the most graphic way. Early each spring, two emissaries from the Museum of Modern Art, Alfred Barr and Dorothy Miller, would head downtown from the Museum on West Fifty-third Street, down to Saint Marks Place, Little Italy, Broome Street and environs, and tour the loft studios of known artists and unknowns alike, looking at everything, talking to one and all, trying to get a line on what was new and significant in order to put together a show in the fall . . . and, well, I mean, my God—from the moment the two of them stepped out on Fifty-third Street to grab a cab, some sort of boho radar began to record their sortie . . . *They're coming!* . . . And rolling across Lower

Manhattan, like the Cosmic Pulse of the theo-
sophists, would be a unitary heartbeat:

*Pick me pick me pick me pick me pick me pick
me pick me . . .* O damnable Uptown!

By all means, deny it if asked!—what one
knows, in one's cheating heart, and what one says
are two different things!

So it was that the art mating ritual developed
early in the century—in Paris, in Rome, in Lon-
don, Berlin, Munich, Vienna, and, not too long
afterward, in New York. As we've just seen, the
ritual has two phases:

(1) The Boho Dance, in which the artist shows
his stuff within the circles, coteries, movements,
isms, of the home neighborhood, bohemia itself,
as if he doesn't care about anything else; as if, in
fact, he has a knife in his teeth against the fashion-
able world uptown.

(2) The Consummation, in which culturati from
that very same world, *le monde,* scout the various
new movements and new artists of bohemia, se-
lect those who seem the most exciting, original,
important, by whatever standards—and shower
them with all the rewards of celebrity.

By the First World War the process was already
like what in the Paris clip joints of the day was
known as an apache dance. The artist was like
the female in the act, stamping her feet, yelling
defiance one moment, feigning indifference the
next, resisting the advances of her pursuer with
absolute contempt . . . more thrashing about . . .
more rake-a-cheek fury . . . more yelling and

Gustave Doré. The Boho Dance

carrying on . . . until finally with one last mighty and marvelously ambiguous shriek—*pain! ecstasy!*—she submits . . . Paff paff paff paff paff . . . How you do it, my boy! . . . and the house lights rise and Everyone, *tout le monde,* applauds . . .

The artist's payoff in this ritual is obvious enough. He stands to gain precisely what Freud says are the goals of the artist: fame, money, and beautiful lovers. But what about *le monde,* the culturati, the social members of the act? What's in it for them? Part of their reward is the ancient and semi-sacred status of Benefactor of the Arts. The arts have always been a doorway into Society, and in the largest cities today the arts—the museum boards, arts councils, fund drives, openings, parties, committee meetings—have completely replaced the churches in this respect. But there is more!

Today there is a peculiarly modern reward that the avant-garde artist can give his benefactor: namely, the feeling that he, like his mate the artist, is separate from and aloof from the bourgeoisie, the middle classes . . . the feeling that he may be *from* the middle class but he is no longer *in* it . . . the feeling that he is a fellow soldier, or at least an aide-de-camp or an honorary cong guerrilla in the vanguard march through the land of the philistines. This is a peculiarly modern need and a peculiarly modern kind of salvation (from the sin of Too Much Money) and something quite common among the well-to-do all over the West,

in Rome and Milan as well as New York. That is why collecting contemporary art, the leading edge, the latest thing, warm and wet from the Loft, appeals specifically to those who feel most uneasy about their own commercial wealth . . . See? I'm not like *them*—those Jaycees, those United Fund chairmen, those Young Presidents, those mindless New York A.C. *goyisheh* hog-jowled, stripe-tied goddamn-good-to-see-you-you-old-bastard-you oyster-bar trenchermen . . . Avant-garde art, more than any other, takes the Mammon and the Moloch out of money, puts Levi's, turtlenecks, muttonchops, and other mantles and laurels of bohemian grace upon it.

That is why collectors today not only seek out the company of, but also want to hang out amidst, lollygag around with, and enter into the milieu of . . . the artists they patronize. They *want* to climb those vertiginous loft building stairs on Howard Street that go up five flights without a single turn or bend—*straight up!* like something out of a casebook dream—to wind up with their hearts ricocheting around in their rib cages with tachycardia from the exertion mainly but also from the anticipation that just beyond this door at the top . . . in this loft . . . lie *the real goods* . . . paintings, sculptures that are indisputably part of the new movement , the new *école,* the new wave . . . something unshrinkable, chipsy, pure cong, bourgeois-proof.

2

The public is not invited
(and never has been)

I'm still a virgin. (Where's the champagne?)

Now we can begin to understand how it happened that the Modernists, Braque & Bros., completed almost all their stylistic innovations before the First World War, and yet Modern Art *seems* to belong to the postwar period. It is simply because the Boho Dance took place before the war and the Consummation took place afterward. This is not what is so often described as the lag between "the artist's discoveries" and "public acceptance." Public? The public plays no part in the process whatsoever. The public is not invited (it gets a printed announcement later).

Le monde, the culturati, are no more a part of "the public," the mob, the middle classes, than the artists are. If it were possible to make one of those marvelous sociometric diagrams that soci-

ologists tried to perfect in the 1950s, in which they tried to trace on a map the daily routes of key people in a community—a blue line for Community Leader A here and a red one for Leader B and a green one for Leader C and a broken sienna one for Bureaucrat Y, and so on—and the lines started moving around and intersecting here and there like a hallucinated Sony solid-state panel—if it were possible to make such a diagram of the art world, we would see that it is made up of (in addition to the artists) about 750 culturati in Rome, 500 in Milan, 1,750 in Paris, 1,250 in London, 2,000 in Berlin, Munich, and Düsseldorf, 3,000 in New York, and perhaps 1,000 scattered about the rest of the known world. That is the art world, approximately 10,000 souls—a mere hamlet!—restricted to *les beaux mondes* of eight cities.

The notion that the public accepts or rejects anything in Modern Art, the notion that the public scorns, ignores, fails to comprehend, allows to wither, crushes the spirit of, or commits any other crime against Art or any individual artist is merely a romantic fiction, a bittersweet Trilby sentiment. The game is completed and the trophies distributed long before the public knows what has happened. The public that buys books in hardcover and paperback by the millions, the public that buys records by the billions and fills stadiums for concerts, the public that spends $100 million on a single movie—this public affects taste, theory,

and artistic outlook in literature, music, and drama, even though courtly elites hang on somewhat desperately in each field. The same has never been true in art. The public whose glorious numbers are recorded in the annual reports of the museums, all those students and bus tours and moms and dads and random intellectuals . . . are merely tourists, autograph seekers, gawkers, parade watchers, so far as the game of Success in Art is concerned. The public is presented with a *fait accompli* and the aforementioned printed announcement, usually in the form of a story or a spread of color pictures in the back pages of *Time*. An announcement, as I say. Not even the most powerful organs of the press, including *Time, Newsweek,* and *The New York Times,* can discover a new artist or certify his worth and make it stick. They can only bring you the news, tell you which artists the *beau* hamlet, Cultureburg, has discovered and certified. They can only bring you the scores.

We can now also begin to see that Modern Art enjoyed all the glories of the Consummation stage after the First World War not because it was "finally understood" or "finally appreciated" but rather because a few fashionable people discovered *their own uses* for it. It was after the First World War that *modern* and *modernistic* came into the language as exciting adjectives (somewhat like *now*, as in the *Now Generation*, during the 1960s). By 1920, in *le monde*, to be fashion-

able was to be *modern,* and Modern Art and the new spirit of the avant-garde were perfectly suited for that vogue.

Picasso is a case in point. Picasso did not begin to become *Picasso,* in the art world or in the press, until he was pushing forty and painted the

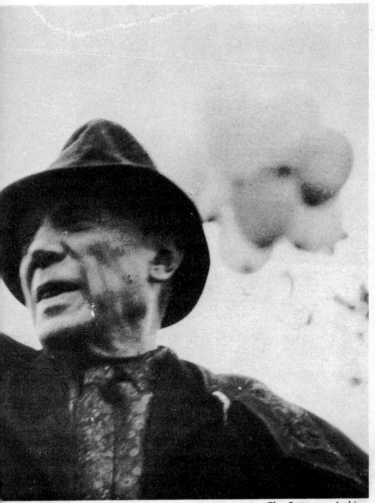

The Bettmann Archive

Pablo Picasso

29

scenery for Diaghilev's Russian ballet in London in 1918. Diaghilev & Co. were a tremendous *succès de scandale* in fashionable London. The wild dervishing of Nijinsky, the lurid costumes—it was all too deliciously *modern* for words. The Modernistic settings by Picasso, André Derain, and (later on) Matisse, were all part of the excitement, and *le monde* loved it. "Art," in Osbert Lancaster's phrase, "came once more to roost among the duchesses."

Picasso, who had once lived in the legendary unlit attic and painted at night with a brush in one hand and a candlestick in the other—Picasso now stayed at the Savoy, had lots of clothes made on Bond Street and nearby, including a set of tails, went to all the best parties (and parties were never better), was set up with highly publicized shows of his paintings, and became a social lion—which he remained, Tales of the Aging Recluse notwithstanding, until he was in his seventies.

Back in Paris, the new Picasso turned up at the theater with his kid gloves, canes, tall hats, capes, and dinner clothes, and the linings gave you a little silk flash every time he wheeled about in the lobby to chat with one of his hellish new friends . . . Our old pal Braque shook his head sadly . . . At least Derain had had the decency to confine himself to a blue serge suit when *he* was being lionized in London, and he had stuck to the company of local bohos in his off hours . . . But Picasso—Braque was like that incorruptible member of the Cénacle of the rue des Quatre Vents,

Daniel D'Arthez, watching the decay of Lucien Chardon in Balzac's *Lost Illusions*. With a sigh Braque waited for his old comrade Pablo's imminent collapse as a painter and a human being . . . But the damnedest thing happened instead! Picasso just kept ascending, to El Dorado, to tremendous wealth but to much more than that, to the sainted status of *Picasso,* to the point where by 1950 he was known at every level of opinion, from *Art News* to the *Daily News,* as *the* painter of the twentieth century. As for Derain and his blue serge suit and Braque and his scruples—the two old boys, both very nearly the same age as Picasso, i.e., about seventy, were remembered in 1950 chiefly as part of the pit crew during Picasso's monumental victory.*

Not to beg the question of differences in talent —but here we have the classic demonstration of the artist who knows how to double-track his way from the Boho Dance to the Consummation as opposed to the artist who gets stuck forever in the Boho Dance. This is an ever-present hazard of the art mating ritual. Truly successful double-tracking requires the artist to be a sincere and committed performer in *both roles.* Many artists become so dedicated to bohemian values, internalize their antibourgeois feelings so profoundly, that they are unable to cut loose, let go, with that cathartic shriek—*pain! ecstasy!* paff paff paff paff paff paff—and submit gracefully to good fortune;

* History, kind history, has improved Braque's status considerably since his death in 1963.

31

the sort of artist, and his name is Legion, who always comes to the black-tie openings at the Museum of Modern Art wearing a dinner jacket and paint-spattered Levi's . . . *I'm still a virgin!* (Where's the champagne?)

3

Le Tout New York
on a Cubist horse

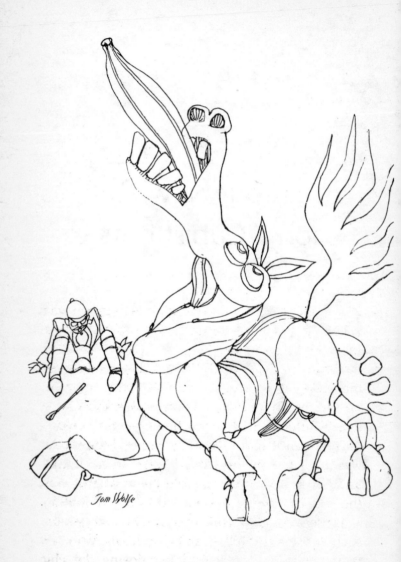

"Hitch your wagon to a star."—Ralph Waldo Emerson

So Modern Art enjoyed a tremendous social boom in Europe in the 1920s. And what about the United States? A painter, Marsden Hartley, wrote in 1921 that "art in America is like a patent medicine or a vacuum cleaner. It can hope for no success until ninety million people know what it is." Bitter stuff! In fact, however, he couldn't have gotten it more precisely wrong. Modern Art was a success in the United States in no time—as soon as a very few people knew what it was, the 400, as it were, as opposed to the 90 million.

These were New Yorkers of wealth and fashion, such as the Rockefellers and Goodyears, who saw their counterparts in London enjoying the chic and excitement of Picasso, Derain, Matisse, and the rest of *Le Moderne* and who wanted to im-

port it for themselves. This they did. Modern Art arrived in the United States in the 1920s not like a rebel commando force but like Standard Oil. By 1929 it had been established, *institutionalized,* in the most overwhelming way: in the form of the Museum of Modern Art. This cathedral of Culture was not exactly the brain child of visionary bohemians. It was founded in John D. Rockefeller, Jr.'s living room, to be exact, with Goodyears, Blisses, and Crowninshields in attendance.

Against such a vogue in *le monde,* conservative critics in New York were helpless. Their very base no longer existed. The doyen of the breed, Royal Cortissoz, made a mighty effort, however. Writing in 1923, at the time of a national debate over immigration (which led to the Immigration Act of 1924), he compared the alien invasion of European modernism to the subversive alien hordes coming in by boat. "Ellis Island art," he called it, no doubt figuring he had come up with a devastating label. Well!—as one can imagine!—how everybody sniggered at poor Mr. Cortissoz over that!

By the mid-1930s, Modern Art was already so chic that corporations held it aloft like a flag to show that they were both up-to-date and enlightened, a force in Culture as well as commerce. The Dole Pineapple Company sent Georgia O'Keeffe and Isamu Noguchi to Hawaii to record their impressions, and the Container Corporation of America was commissioning abstract work by Fernand Léger, Henry Moore, and others. This led

to the Container Corporation's long-running advertising campaign, the Great Ideas of Western Man series, in which it would run a Great Idea by a noted savant at the top of the page, one of them being " 'Hitch your wagon to a star'—Ralph Waldo Emerson." Underneath would be a picture of a Cubist horse strangling on a banana.

Naturally the chic of *Le Moderne* put a heavy burden on theory. Each new movement, each new *ism* in Modern Art was a declaration by the artists that they had a new way of seeing which the rest of the world (read: the bourgeoisie) couldn't comprehend. "We understand!" said the culturati, thereby separating themselves also from the herd. But what inna namea Christ *were* the artists seeing? This was where theory came in. A hundred years before, Art Theory had merely been something that enriched one's conversation in matters of Culture. Now it was an absolute necessity. It was no longer background music. It was an essential hormone in the mating ritual. *All we ask for is a few lines of explanation!* You say Meret Oppenheim's *Fur-Covered Cup, Saucer and Spoon* (the *pièce de résistance* of the Museum of Modern Art's Surrealism show in December 1936) is an example of the Surrealist principle of displacement? You say the texture of one material—fur—has been imposed upon the forms of others—china and tableware—in order to split the oral, the tactile, and the visual into three critically injured but for the first time fiercely independent parties in the subconscious? Fine. To

get the word was to understand. The Dadaists professed to be furious over this obscene embrace by the very people they had been attacking. "Any work of art that can be understood is the product of a journalist," said Tristan Tzara's Dada manifesto. "So what?" came the reply. ("You dismal little Rumanian.") Even an explanation of why one couldn't accept something, including Dada, was explanation enough to accept it.

Yet Theory did not come fully into its own, triumphant, transcendent, more important than painting and sculpture themselves, until after the Second World War. Theory, this first-class coach on the Freight Train of History (to use a phrase from the period), was held back by a little matter that seldom finds its way into the art histories today, as if what the Freudians call "the amnesia of childhood" were at work. For more than ten years, from about 1930 to 1941, the artists themselves, in Europe and America, suspended the Modern movement . . . for the duration, as it were . . . They called it off! They suddenly returned to "literary" realism of the most obvious sort, a genre known as Social Realism.

Left politics did that for them. Left politicians said, in effect: You artists claim to be dedicated to an antibourgeois life. Well, the hour has now come to stop merely posing and to take action, to turn your art into a weapon. Translation: propaganda paintings. The influence of Left politics was so strong within the art world during the 1930s that Social Realism became not a style of

the period but *the* style of the period. Even the most dedicated Modernists were intimidated. Years later Barnett Newman wrote that the "shouting dogmatists, Marxist, Leninist, Stalinist, and Trotskyite" created "an intellectual prison that locked one in tight." I detect considerable amnesia today on that point. All best forgotten! Artists whose names exist as little more than footnotes today—William Gropper, Ben Shahn, Jack Levine—were *giants* as long as the martial music of the mimeograph machines rolled on in a thousand Protest Committee rooms. For any prominent critic of the time to have written off Ben Shahn as a commercial illustrator, as Barbara Rose did recently, would have touched off a brawl. Today no one cares, for Social Realism evaporated with the political atmosphere that generated it. By 1946 the scene had cleared for the art of our day—an art more truly Literary than anything ever roared against in the wildest angers of the Fauvists and Cubists.

4

Greenberg, Rosenberg & Flat

When Flat was God. Using the impastometer

None of the Abstract Expressionist paintings that remain from the palmy days of 1946 to 1960—and precious few are still hanging except in museums and the guest bedrooms of Long Island beachhouses, back there with the iron bedstead whose joints don't gee, the Russel Wright water pitcher left over from the set of dishes the newly-weds bought for their first apartment after the war, and an Emerson radio with tubes and a short-wave band . . . none of the paintings, as I say, not even Jackson Pollock's and Willem de Kooning's, makes quite as perfect a memorial to that brave and confident little epoch as the Theories. As for the paintings—*de gustibus non disputandum est.* But the theories, I insist, were *beautiful*.

Theories? They were more than theories, they were mental constructs. No, more than that even

. . . veritable edifices behind the eyeballs they were . . . castles in the cortex . . . mezuzahs on the pyramids of Betz . . . crystalline . . . comparable in their bizarre refinements to medieval Scholasticism.

We can understand the spellbinding effect these theories had, however, only by keeping in mind what we have noted so far: (1) the art world is a small town; (2) part of the small town, *le monde,* always looks to the other, bohemia, for *the new wave* and is primed to believe in it; (3) bohemia is made up of *cénacles,* schools, coteries, circles, cliques. Consequently, should one *cénacle* come to dominate bohemia, its views might very well dominate the entire small town (a.k.a. "the art world"), all the way from the Chambers Street station to Eighty-ninth and Fifth.

And that is precisely what happened in New York after the Second World War in the era of Abstract Expressionism, when New York replaced Paris (as one was so often reminded) as the county seat of Modernism.

During the Dark Ages—i.e., the 1930s interlude of Social Realism—small *cénacles* of Modernists kept the faith alive down in bohemia, down below Fourteenth Street. They were like a real underground, for a change—in hiding this time not from that rather metaphysical menace, the bourgeoisie, but from their own comrade bohemian drillmasters, the aforementioned "shouting dogmatists" of the Left. Even Franz Kline, the abstract painter's abstract painter, was dutifully cranking

out paintings of unemployed Negroes, crippled war veterans, and the ubiquitous workers with the open blue work shirts and necks wider than their heads. But there were those who kept Modernism alive . . .

The most influential *cénacle* centered upon Hans Hofmann, a German painter in his mid-fifties who simply ignored the drillmasters and ran his art school in Greenwich Village as a philosophical outpost for *l'art pour l'art* and abstract painting. Another *cénacle* met in the studio of a sculptor, Ibram Lassaw; this one included Ad Reinhardt and Josef Albers and eventually grew into an organization called American Abstract Artists. The Triple A seemed to be animated mainly by anger at *le monde,* and the Whitney Museum and the Museum of Modern Art particularly, for patronizing European abstract work (and, if one need edit, not theirs). Another circle of friends, Adolph Gottlieb, Mark Rothko, and Milton Avery among them, was known as "the Ten." Another gathered about John Graham and included de Kooning, Arshile Gorky, Stuart Davis, and David Smith. Still another included Roberto Matta, William Baziotes, and Jackson Pollock, who was married to a member of the Hofmann *cénacle,* Lee Krasner, bringing us full circle.

All these circles and coteries came together after the war as the *cénacle des cénacles,* the New York School, or Tenth Street School, creators of Abstract Expressionism. Most of these people had

slogged their way through the Depression with great difficulty, and their mood tended toward bohemianism of the High Seriousness vein.

Two of their main meeting places, the Subjects of the Artist School and The Club, were on East Eighth Street, and the other, the Cedar Tavern, was on University Place. But the galleries that

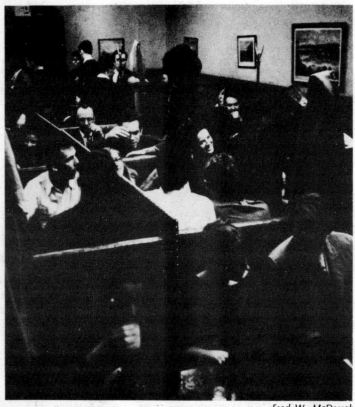

Fred W. McDarrah

The Cedar Tavern, scene of the *cénacle des cénacles* and one of Cultureburg's most prestigious boho cafés of all time, comparable to the Five Spot, the White Horse, and Max's Kansas City. "Hi, Marko!"

showed their work, such as the Area and the Hilda
Carmel, were on Tenth Street, and that was the
name that caught on. Within *le monde,* "going
down to Tenth Street" was like the Saturday pil-
grimage "down to Soho" today. In any event, this
cénacle was soon so big and so influential that
the regular Friday night meetings at The Club
became like town meetings for the entire New
York art scene, attracting dealers, collectors, up-
town curators like Alfred Barr, critics, and just
about any other culturati who could wangle their
way in.

The great theorists to come out of this *cénacle
des cénacles* were Clement Greenberg and Harold
Rosenberg. Both had been involved in the Lower
Manhattan Left literary politics of the 1930s, then
became more and more purely theorists, critics,
aestheticians in the 1940s. More to the point, both
had been friends of various abstract artists even
during the Freeze. Greenberg had been a regular
in the Hofmann *cénacle*—and it was essentially
Hofmann's ideas and Hofmann's emphasis on
purity *purity* **purity** that were about to sweep
Cultureburg, via Greenberg. One secret of Green-
berg's and Rosenberg's astounding success, then,
was that they were not like uptown critics—they
were not *mere* critics: they spoke as the voice of
bohemia . . . and naturally *le monde* listened.

To describe this, the well-placed platform they
spoke from, is not to downgrade the two men's
peculiar genius. Greenberg, in particular, radiated
a sense of absolute *authority.* He was not a very

prepossessing individual at first glance. He spoke in fits and starts one minute and drawls the next. But somehow one couldn't help but pay attention. Likewise his prose style: he would veer from the most skull-crushing Göttingen Scholar tautologies, "essences" and "purities" and "opticalities" and "formal factors" and "logics of readjustment" and God knows what else . . . to cries of despair and outrage such as would have embarrassed Shelley. In a famous essay in *Horizon* in 1947 he said the entire future of art in America was in the hands of fifty brave but anonymous and beleaguered artists "south of 34th Street" who were about to be wiped out at any moment. By whom—by what? Why, by the "dull horror" of American life. "Their isolation is inconceivably crushing, unbroken, damning," said Greenberg. "That anyone can produce art on a respectable level in this situation is highly improbable. What can fifty do against a hundred and forty million?"

Fifty against 140 million! Beautiful; he had out-hartleyed Marsden Hartley; Hartley's scouting report on the enemy back in 1921 listed only 90 million. It was all sheer rhetoric, of course, the antibourgeois sing-along of bohemia, standard since the 1840s, as natural as breathing by now and quite marvelously devoid of any rational content—and yet Greenberg pulled it off with—well, not just with authority but with *moral* authority. When Greenberg spoke, it was as if not merely the future of Art were at stake but the very quality, the very *possibility*, of civilization in America. His

fury seemed to come out of an implacable in-sistence on *purity*. He saw Modernism as heading toward a certain inevitable conclusion, through its own internal logic, just as Marxists saw Western society as heading irrevocably toward the dic-tatorship of the proletariat and an ensuing nir-vana. In Greenberg's eyes, the Freight Train of Art History had a specific destination. He called for "self-criticism" and "self-definition"—"self-definition with a vengeance," he said. It was time to clear the tracks at last of all the remaining rubble of the pre-Modern way of painting. And just what was this destination? On this point Greenberg couldn't have been clearer: *Flatness.*

The general theory went as follows: as the Cubists and other early Modernists had correctly realized, a painting was not a window through which one could peer into the distance. The

© *1973 Arnold Newman*

Clement Greenberg

three-dimensional effects were sheer illusion (et ergo ersatz). A painting was a flat surface with paint on it. Earlier abstract artists had understood the importance of flatness in the simple sense of painting in two dimensions, but they hadn't known how to go beyond that. They still used paint in such a way that it divided neatly into lines, forms, contours, and colors, just as it had in pre-Modern days. What was needed was *purity*— a style in which lines, forms, contours, colors all became unified on the flat surface.

This business of flatness became quite an issue; an obsession, one might say. The question of what an artist could or could not do without violating the principle of Flatness—"the integrity of the picture plane," as it became known—inspired such subtle distinctions, such exquisitely mini-aturized hypotheses, such stereotactic microelec-trode needle-implant hostilities, such brilliant if ever-decreasing tighter-turning spirals of logic . . . that it compares admirably with the most famous of all questions that remain from the debates of the Scholastics: "How many angels can dance on the head of a pin?"

Most of the theory up to 1950 was Greenbergian in origin. Enter Rosenberg. Rosenberg came up with a higher synthesis, a theory that combined Greenberg's formal purity with something that had been lacking in abstract art from the early Synthetic Cubist days and ever since: namely, the emotional wallop of the old realistic pre-Modern

pictures. This was a question that had troubled Picasso throughout the 1930s. Any return to realism was out, of course, but Rosenberg had a solution: "Action Painting," which became the single most famous phrase of the period (a fact that did not please Greenberg).

Harold Rosenberg

"At a certain moment the canvas began to appear to one American painter after another as an arena in which to act," said Rosenberg. "What was to go on the canvas was not a picture but an event." The vision that Rosenberg inspired caught the public imagination for a time (the actual *public*!) as well as that of more painters, professional and amateur, than one is likely to want to recall. It was of Action Painter . . . a Promethean artist gorged with emotion and overloaded with paint, hurling himself and his brushes at the canvas as if in hand-to-hand combat with Fate. *There!* . . . *there!* . . . *there* in those furious swipes of the

brush on canvas, in those splatters of unchained id, one could see the artist's emotion itself—still alive!—in the finished product. (And see? All the picture-plane integrity a reasonable man could ask for, and lines that are forms and forms that are colors and colors that are both.)

It is important to repeat that Greenberg and Rosenberg did not create their theories in a vacuum or simply turn up with them one day like tablets brought down from atop Green Mountain or Red Mountain (as B. H. Friedman once called the two men). As *tout le monde* understood, they were not only theories but . . . hot news, straight from the studios, from the scene. Rosenberg's famous Action Painting piece in *Art News* did not mention a single new artist by name, but *tout le monde* knew that when he spoke of "one American painter after another" taking up the style, he was really talking about one American painter: his friend de Kooning . . . or perhaps de Kooning and his *cénacle*. Greenberg's main man, as Everybody knew, was his friend Pollock.

Greenberg didn't discover Pollock or even create his reputation, as was said so often later on. Damnable Uptown did that. *Pick me!* Peggy Guggenheim picked Pollock. He was a nameless down-and-out boho Cubist. She was the niece of Solomon (Guggenheim Museum) Guggenheim and the center of the most chic Uptown art circle in New York in the 1940s, a circle featuring famous Modern artists from Europe (including her husband, Max Ernst) who were fleeing the war,

De Kooning in his studio in mid-Action:
the bull—or the matador—as you like it—
pulls back and takes a few snorts of reflection
before the next collision with Fate

53

Uptown intellectuals such as Alfred Barr and
James Johnson Sweeney of the Museum of Modern Art, and young boho protégés such as two
members of Pollock's *cénacle*, Baziotes and Rob-

Jackson Pollock's *The She Wolf* (1943), the painting
the Museum of Modern Art bought as its part in Pollock's
Consummation. The style is halfway between Pollock's

ert Motherwell. In a single year, 1943, Peggy Guggenheim met Pollock through Baziotes and Motherwell, gave him a monthly stipend, got him moving in the direction of Surrealist "automatic

Collection, The Museum of Modern Art, New York

early Picasso-Cubist style and the completely abstract
"drip" style for which Pollock is best known.
That thick, fuliginous flatness got me in its spell . . .

writing" (she loved Surrealism), set him up on Fifty-seventh Street—Uptown Street of Dreams!—with his first show—in the most chic Modernist salon in the history of New York, her own Art of This Century Gallery, with its marvelous Surrealist Room, where the pictures were mounted on baseball bats—got Sweeney to write the catalogue introduction, in prose that ranged from merely rosy to deep purple dreams—and Barr inducted one of the paintings, *The She Wolf,* into the Museum of Modern Art's Permanent Collection—and Motherwell wrote a rave for *Partisan Review*—and Greenberg wrote a super-rave for *The Nation* . . . and, well, Greenberg was rather late getting into the loop, if anything. The Consummation was complete and Pollock was a Success before the last painting was hung and the doors were opened and the first Manhattan was poured (remember Manhattans?) on opening night. To that extent Greenberg was just an ordinary reporter bringing you the latest news.

But Greenberg did something more than discover Pollock or establish him. He used Pollock's certified success to put over Flatness as *the* theory—the theoretical breakthrough of Einstein-scale authority—of the entire new wave of the Tenth Street *cénacle des cénacles.*

"Pollock's strength," he would say, "lies in the emphatic surfaces of his pictures, which it is his concern to maintain and intensify in all that thick, fuliginous flatness which began—but only began—to be the strong point of late Cubism." And all

through bohemia the melody played . . . *That thick, fuliginous flatness got me in its spell . . .* "It is the tension inherent in the constructed, re-created flatness of the surface," Greenberg would say, "that produces the strength of his art" . . . *That constructed, re-created flatness that you weave so well . . .* "his concentration on surface texture and tactile qualities" . . . *Those famous paint-flings on that picture plane . . .*

Ah, the music was playing! And Clement Greenberg was the composer! Other artists were picking up on his theories and Rosenberg's, sometimes by reading them in the journals—*Partisan Review, The Nation, Horizon*—but more often in conversation. With The Club going down on Eighth Street the artists of bohemia were now meeting all the time, every day, and talking up a storm. They outtalked any ten canasta clubs from Oceanside and Cedarhurst.

Greenberg was no slouch at conversation himself, despite his jerky windups and his not very elegant deliveries. Somehow the rough edges went perfectly with the *moral conviction* that seemed to radiate from his eyeballs. A forty-one-year-old Washington, D.C., artist named Morris Louis came to New York in 1953 to try to get a line on what was going on in this new wave, and he had some long talks with Greenberg, and the whole experience changed his life. He went back to Washington and began thinking. *Flatness,* the man had said . . . (You bet he had) . . . The spark

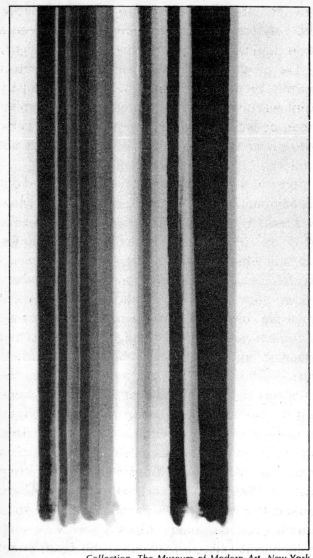

Collection, The Museum of Modern Art, New York

Morris Louis, *Third Element*, 1962.
No painter ever took the Word more literally;
with the possible exception of Frank Stella

58

flew, and Louis saw the future with great clarity. The very use of thick oil paint itself had been a crime against flatness, a violation of the integrity of the picture plane, all these years . . . But of course! Even in the hands of Picasso, ordinary paint was likely to build up as much as a millimeter or two *above* mean canvas level! And as for the new Picasso—i.e., Pollock—my God, get out a ruler!

So Louis used unprimed canvas and thinned out his paint until it *soaked right into* the canvas when he brushed it on. He could put a painting on the floor and lie on top of the canvas and cock his eye sideways like a robin and look along the surface of the canvas—and he had done it! Nothing existed above or below the picture plane, except for a few ultramicroscopic wisps of cotton fray, and what reasonable person could count that against him . . . No, everything now existed precisely *in* the picture plane and nowhere else. The paint was the picture plane, and the picture plane was the paint. Did I hear the word *flat?*—well, try to out-flat this, you young Gotham rascals! Thus was born an offshoot of Abstract Expressionism known as the Washington School. A man from Mars or Chester, Pa., incidentally, would have looked at a Morris Louis painting and seen rows of rather watery-looking stripes.

But the Washington School or the Tenth Street School was no place for creatures from out of state unless they'd had their coats pulled, unless they'd been briefed on the theories. In no time

these theories of flatness, of abstractness, of pure form and pure color, of expressive brushwork ("action") seemed no longer mere theories but axioms, part of the given, as basic as the Four Humors had once seemed in any consideration of human health. Not to know about these things was not to have the Word.

The Word—but exactly. A curious change was taking place at the very core of the business of being a painter. Early Modernism had been a reaction to nineteenth-century realism, an abstraction of it, a diagram of it, to borrow John Berger's phrase, just as a blueprint is a diagram of a house. But this Abstract Expressionism of the Tenth Street School was a reaction to earlier Modernism itself, to Cubism chiefly. It was an abstraction of an abstraction, a blueprint of the blueprint, a diagram of the diagram—and a diagram of a diagram is metaphysics. Anyone who tries making a diagram of a diagram will see why. Metaphysics can be dazzling!—as dazzling as the Scholastics and their wing commands of Angels and Departed Souls. But somehow the ethereal little dears are inapprehensible without words. In short, the new order of things in the art world was: first you get the Word, and then you can see.

The artists themselves didn't seem to have the faintest notion of how primary Theory was becoming. I wonder if the theorists themselves did. All of them, artists and theorists, were talking as if their conscious aim was to create a totally immediate art, lucid, stripped of all the dreadful

baggage of history, an art fully revealed, honest, as honest as the flat-out integral picture plane. "Aesthetics is for the artists as ornithology is for the birds," said Barnett Newman in a much-repeated *mot*. And yet Newman himself happened to be one of the most incessant theoreticians on Eighth Street, and his work showed it. He spent the last twenty-two years of his life studying the problems (if any) of dealing with big areas of color divided by stripes . . . on a flat picture plane.

Hans Namuth

Barnett Newman

Hans Namuth

Jackson Pollock

Nobody was immune to theory any longer. Pollock would say things like "Cézanne didn't create theories. They're after the fact." He was only whistling "Dixie." The fact was that theories—Greenberg's—about Pollock—were beginning to affect Pollock. Greenberg hadn't created Pollock's reputation, but he *was* its curator, custodian, brass polisher, and repairman, and he was terrific at it. With each new article Greenberg edged Pollock's status a little higher, from "among the strongest" American abstract artists ever to "the strongest painter of his generation" in America to "the most powerful painter in contemporary America" to a neck-and-neck competition with John Marin (John Marin!) for the title of "the greatest American painter of the twentieth century." To the few remaining dissidents, Uptown or Downtown, who still pulled long faces and said Pollock's work looked terribly "muddy" or "chaotic" or simply "ugly," Greenberg had a marvelous comeback: but of course!—"all profoundly original art looks ugly at first." Well . . . yes! *That's . . . right!* In an age of avant-gardism, when practically everybody in Cultureburg could remember some new *ism* which he "hadn't gotten" at first, this Greenberg dictum seemed to be a pivotal insight of Modernism, the golden *aperçu*. To collectors, curators, and even some dealers, new work that looked genuinely *ugly* . . . began to taken on a strange new glow . . .

In any event, if Greenberg was right about Pollock's status in the world of art—and Pollock

wasn't arguing—then he must also be right about the theories. So Pollock started pushing his work in the direction the theories went. Onward! Flatter! More fuliginous! More "over-all evenness"! But fewer gaping holes! (Greenberg thought Pollock sometimes left "gaping holes" in the otherwise "integrated plane.") Greenberg took to going by Pollock's studio and giving on-the-spot critiques.

Soon Pollock was having a generally hard time figuring out where the boundary was between Himself—old Jack—and his Reputation or whether there was any. Pollock was the classic case of the artist hopelessly stuck between the Boho Dance and the Consummation. Pollock had internalized the usual antibourgeois bohemian values in huge gulps during the days of the Depression, when he was a boho on the dole and doing odd jobs such as hand-painting neckties (during that short-lived men's fashion). The Consummation came so fast —in that one year, 1943—Pollock never could manage the double-tracking. He got forever stuck halfway. Here was the archetypical Pollock gesture: one night he arrives drunk at Peggy Guggenheim's house during a party for a lot of swell people. So he takes off his clothes in another room and comes walking into the living room stark naked and urinates in the fireplace. On the other hand, neither that night nor thereafter did he give up coming to Peggy Guggenheim's house, where all those swell people were. He would insist on going to the old Stork Club or to 21 with-

out a necktie to prove he could get in anyway thanks to "my reputation"—and if he did, he would make sure he got drunk enough and rude enough to get thrown out. They had to accept him Uptown, but he couldn't stand liking it.

Despite his huge reputation, his work did not sell well, and he barely scraped by financially— which satisfied his boho soul on the one hand but also made him scream (stuck, as he was, in the doorway): *If I'm so terrific, why ain't I rich?* And this gets down to the problems that collectors were beginning to have with Abstract Expression- ism and the abstract styles that followed, such as the Washington School. Most of early Modernism, and particularly Cubism, was only partly abstract. The creatures in Matisse's *Joie de Vivre*, which seemed so outrageously abstract in 1905, may not have been nice concupiscent little lamb chops such as were available in Max Klinger's *The Judg- ment of Paris*, but they were nude women all the same. For many collectors it was enough to know the general theory and the fact that here were nudes done in "the new [Fauvist, Cubist, Expres- sionist, Surrealist, or whatever] way." But with Abstract Expressionism and what came after it, they had to have . . . the Word. There were no two ways about it. There was no use whatsoever in looking at a picture without knowing about Flatness and associated theorems.

How manfully they tried! How they squinted and put their fingers under their eyelids in order to focus more sharply (as Greenberg was said

to do) . . . how they tried to *internalize* the
theories to the point where they could *feel* a
tingle or two *at the very moment* they looked at
an abstract painting . . . without first having to
give the script a little run-through in their minds.
And some succeeded. But *all tried!* I stress that in
light of the terrible charges some of the Abstrac-
tionists and their theorists are making today
against the collectors . . . calling them *philistines*
and *nouveaux-riches, status strivers* who only *pre-
tended* to like abstract art, even during the heyday
of the 1950s. Which is to say: You were nothing
but fat middle-class fakes all along! You never
had a true antibourgeois bone in your bodies!

Ah, ingratitude, ingratitude . . . *ars longa memoria
brevis* . . . The truth was that the collectors wanted
nothing more than to believe wholeheartedly, to
march with the Abstract Expressionists as aides-
de-cong through the land of the philistines. They
believed, along with the artists, that Abstract Ex-
pressionism was *the final form,* that painting had
at last gone extra-atmospheric, into outer space,
into a universe of pure forms and pure colors.
Even Cultureburg's intellectual fringe, the journal-
ists of the popular press, reported the news in
good faith, without a snigger. In 1949 *Life* maga-
zine gave Pollock a three-page spread, two of
them in color, headed: "JACKSON POLLOCK. Is he
the greatest living painter in the United States?"
The whole piece was clearly derived from the
say-so of Greenberg, whom *Life* identified as "a

formidably high-brow New York critic." *Life*, *Time*, *Newsweek* continued to follow Abstract Expressionism, in color, with the occasional 22-caliber punnery about "Jack the Dripper" (Pollock) who says little and "stands on his painting," but also with the clear message that this was what was important in contemporary art.

In fact, the press was so attentive that Harold Rosenberg, as well as Pollock, wondered why so little Abstract Expressionism was being bought. "Considering the degree to which it is publicized and feted," Rosenberg said, "vanguard painting is hardly bought at all." Here Rosenberg was merely betraying the art world's blindness toward its own strategies. He seemed to believe that there was an art public in the same sense that there was a reading public and that, consequently, there should be some sort of public demand for the latest art objects. He was doing the usual, in other words. First you do everything possible to make sure your world is antibourgeois, that it defies bourgeois tastes, that it mystifies the mob, the public, that it outdistances the insensible middle-class multitudes by light-years of subtlety and intellect—and then, having succeeded admirably, you ask with a sense of *See-what-I-mean?* outrage: look, they don't even buy our products! (Usually referred to as "quality art.") The art world had been successfully restricted to about 10,000 souls worldwide, the *beaux mondes* of a few metropolises. Of these, perhaps 2,000 were collectors, and probably no more than 300—worldwide—

bought current work (this year's, last year's, the year-before's) with any regularity; of these, perhaps 90 lived in the United States.

There were brave and patriotic collectors who created a little flurry of activity on the Abstract Expressionist market in the late 1950s, but in general this type of painting was depreciating faster than a Pontiac Bonneville once it left the showroom. The resale market was a shambles. Without the museums to step in here and there, to buy in the name of history, Abstract Expressionism was becoming a real beached whale commercially. The deep-down mutter-to-myself truth was that the collectors, despite their fervent desire to be virtuous, had never been able to build up any gusto for Abstract Expressionism. Somehow that six-flight walk up the spiral staircase of Theory took the wind out of you.

I once heard Robert Scull say, "Abstract Expressionism was a little club down on Tenth Street. There were never more than 100 people in on it." Scull was a collector from a later, enemy camp, Pop Art, and he may have set the figure too low, but I suspect that he was, at the core, correct. As was the case with Swedenborgianism and Rosicrucianism, Abstract Expressionism's makers and theorists and its truly committed audience seem to have been one and the same. Who else was there, really, but the old *cénacles* down on Eighth Street . . . unless you also count the interior decorators who did *truly love* to use Abstract Expressionist paintings with those large flat areas (O

integral planes!) of bright color to set off the stark white apartments that were so fashionable at the time.

But to say that Abstract Expressionism was a baby that only its parents could love is not to downgrade its theorists in the slightest. Quite the opposite. For a good fifteen years, with nothing going for them except brain power and stupend-ous rectitude and the peculiar makeup of the art world, they projected this style, this unloved brat of theirs, until it filled up the screen of art history.

5

Hello, Steinberg
(Goodbye, Greenberg)
(You, too, Rosenberg)
(Joy returns
to Cultureburg)

Andy Warhol. Nothing is more bourgeois
than to be afraid to look bourgeois

W e may state it as a principle at this point that collectors of contemporary art do not want to buy highly abstract art unless it's the only game in town. They will always prefer realistic art instead—as long as someone in authority assures them that it is (a) new, and (b) not realistic. To understand this contradiction is to understand what happened next: Pop Art.

One day—in 1963, it must have been—I ran into a magazine editor, a culturatus of sorts, and I happened to bring up the subject of Abstract Expressionism, whereupon he told me with a tone that indicated I must be the only person in town who hadn't gotten the inside news: "Listen, Abstract Expressionism is dead. It's been finished off by a professor at Hunter College, a guy named Leo Steinberg."

I don't know that Steinberg finished off Abstract Expressionism. It only needed a little push. But Steinberg was certainly one of the authorities who made it okay to like Pop Art.

Mark Feldstein

Leo Steinberg

The Pop Art era is usually dated from the first one-man show of Jasper Johns at the Leo Castelli Gallery, January 20 to February 8, 1958, with paintings of American flags, letters of the alphabet, rows of numbers, and archery targets. Johns and his friend Robert Rauschenberg were the major figures in a *cénacle* of younger artists who in the 1950s began to react against the by-now sainted Abstract Expressionists. Young artists had started pouring into Lower Manhattan and heading, naturally, for legendary spots like the Cedar

74

Tavern. They liked to pop into the Cedar with their toggle coats and corduroys and other proper boho gear on, like young recruits ready for the battle against the blind public, and they'd say,

Hans Namuth

Hans Namuth

Jasper Johns and Robert Rauschenberg, the two early imps of Pop Art

"Hi, Bill!" (de Kooning), "Hi, Franz!" (Kline), "Whaddaya say, Marko!" (Rothko). But the old boys didn't exactly feel like being buddies and sharing the glow with these hideously chummy young nobodies. All right . . . So Johns and Rauschenberg started zapping the old bastards in their weakest spot: their dreadful solemnity and High Seriousness. The Tenth Street *cénacle des cénacles* was full of artists who were so *spiritual* that they never even got as far as Pollock had in double-tracking out of the Boho Dance and into

75

the Consummation. They remained psychologically (and, by and by, resentfully) trapped in bohemia. Rothko refused to participate in a Whitney Museum annual show in order to safeguard "the life my pictures will lead in the world," and refused (or claimed to refuse) to set foot in any Uptown art gallery unless some friend of his was having an opening. So Rauschenberg took to giving interviews in the art magazines in which he said that being an artist was no different, spiritually, from being a cargo humper or a file clerk or anything else. He exhibited *oeuvres* such as three Coca-Cola bottles, the actual bottles, surmounted by a pair of eagle wings. But all that was too easy to write off as mere Dada. Johns's 1958 show was something else again. It wasn't a coarse gesture; it was mighty cool . . . and something an ambitious young critic could fly with.

So Leo Steinberg, along with William Rubin, another theorist (and collector), depicted Johns's work as a newer, higher synthesis. The central arguing point? But of course—our old friend Flatness.

The new theory went as follows. Johns had chosen real subjects such as flags and numbers and letters and targets that were flat *by their very nature*. They were *born* to be flat, you might say. Thereby Johns was achieving an amazing thing. He was bringing real subjects into Modern painting but in a way that neither violated the law of Flatness nor introduced "literary" content. On the contrary: he was converting pieces of every-

day communication—flags and numbers—into art objects . . . and thereby *de*-literalizing them! Were they content or were they form? They were neither! They were a higher synthesis. "An amazing result," said Steinberg.

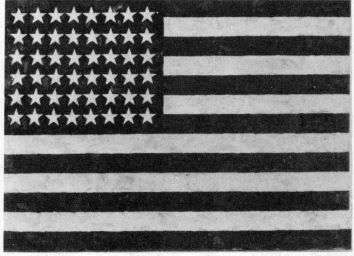

Collection Mrs. Leo Castelli. Courtesy Leo Castelli Gallery
Jasper Johns's *Flag*, 1958. *Born* to be flat

Then Steinberg noticed something else. Johns had covered his flat signs in short, choppy Cézanne-like brushstrokes. Somehow this made them look flatter than ever . . . In fact, his flatness exposed once and for all the *pseudo*-flatness of Abstract Expressionists like de Kooning and Pollock. The jig was up! Steinberg was now ready to give the *coup de grâce* to Clement Greenberg.

Greenberg had always argued that the Old Masters, the classic 3-D realists, had created "an illusion of space into which one could imagine

oneself walking," whereas—to the everlasting
glory of Modernism—you couldn't walk into a
Modernist painting and least of all into an Ab-
stract Expressionist painting. (Too honest, too flat
for any such ersatz experience.) Just a minute,
said Steinberg. That's all well and good, but you're
talking about a "pre-industrial standard of loco-
motion," i.e., *walking*. Perhaps you can't *walk*
into an Abstract Expressionist painting—but you
can *fly* through. Right! You could take a space-
ship! Just look at a de Kooning or a Rothko or a
Franz Kline. Look at that "airy" quality, those
"areas floating in space," those cloud formations,
all that "illusionistic space" with its evocations of
intergalactic travel. Why, you could sail through
a de Kooning in a Mercury capsule or a Soyuz
any day in the week! All along, the Abstract Ex-
pressionists had been dealing in "open atmo-
spheric effects." It was aerial "double dealing,"
and it did "clearly deny and dissemble the pic-
ture's material surface"—and nobody had ever
blown the whistle on them!

Well, it was all now blown for Abstract Expres-
sionism. Steinberg, with an assist from Rubin and
from another theoretician, Lawrence Alloway,
removed the cataracts from everybody's eyes
overnight. Steinberg put across many of his ideas
in a series of lectures at the Museum of Modern
Art in 1960. The auditorium seats only 480, but
with Cultureburg being such a small town—and
the Museum looming so large in it—that platform
was just right: his ideas spread as fast as Green-

berg's had fifteen years before. Steinberg's manner was perfect for the new era. Where Greenberg was a theologian always on the edge of outrage and hostility, like Jonathan Edwards or Savonarola, Steinberg was cool, even a bit ironic. He was the young scholar, the historian; serious but urbane.

As soon as he realized what Johns's work meant, said Steinberg, "the pictures of de Kooning and Kline, it seemed to me, were suddenly tossed into one pot with Rembrandt and Giotto. All alike sud-

Collection, The Museum of Modern Art, New York

Franz Kline's *Painting Number Two*, 1954.
Can a spaceship penetrate a Kline?

denly became painters of illusion." Later on, Steinberg changed that to "Watteau and Giotto"; perhaps for the crazy trans-lingual rhyme, which,

I must say, I like . . . or perhaps because being tossed into the same pot with Rembrandt, even by Leo Steinberg, was a fate that any artist, de Kooning included, might not mind terribly.

This may have been the end of Abstract Expressionism, but for Art Theory it was a fine, a rare, a beautiful, an *artistic* triumph. With that soaring aerial *aperçu* of Leo Steinberg's, Art Theory reached a heavenly plane, right up there with Paracelsus, Meister Eckhart, Christian Rosenkreutz, Duns Scotus, and the Scholastics . . . "How many angels can dance on the head of a pin?" That was one a question of infinite subtlety. Ah, yes! But consider: "Can a spaceship penetrate a de Kooning?"

Jasper Johns's show was the perfect exhibition for the new age of Theory. He had intentionally devised it as an art lecture in pictures. It was like one of those puzzles in the 59-cent playbooks on sale in the wire racks in the supermarkets, in which you're invited to write down the sentences that the pictures create:

But wasn't there something just the least bit incestuous about this tendency of contemporary art to use previous styles of art as its point of reference? Early Modernism was a comment on academic realism, and Abstract Expressionism was a comment on early Modernism, and now Pop Art was a comment on Abstract Expressionism— wasn't there something slightly narrow, clubby, *ingrown* about it? Not at all, said Steinberg, whereupon he formulated one of the great axioms of the period: "Whatever else it may be, all great art is about art." Steinberg's evidence for this theory was far more subtle than convincing. *Sophistry,* I believe, is the word. He would cite Renaissance paintings with figures in the frames pointing at the main picture. (See? They're *commenting on* art.) But never mind . . . Steinberg's axiom was another one that inspired the profound *"That's . . . right!"* reaction throughout the art scene. Steinberg's own qualifier was dropped, and the *mot* became simply: "All great art is about art." That was like DDT for a lot of doubts that might otherwise have beset true believers over the next few years.

Meanwhile, Clement Greenberg and Harold Rosenberg made a grave tactical error. They simply denounced Pop Art. That was a gigantic blunder. Greenberg, above all, as the man who came up with the peerless Modern line, "All profoundly original work looks ugly at first," should have realized that in an age of avant-gardism no critic can stop a new style by meeting it head-on.

To be against what is new is not to be modern. Not to be modern is to write yourself out of the scene. Not to be in the scene is to be nowhere. No, in an age of avant-gardism the only possible strategy to counter a new style which you detest is to *leapfrog* it. You abandon your old position and your old artists, leaping *over* the new style, land beyond it, point back to it, and say: "Oh, that's nothing. I've found something *newer* and *better* . . . way out here." This would dawn on Greenberg later.

Steinberg could attack Abstract Expressionism precisely because he was saying, "I've found something newer and better." But one will note that at no time does he attack the premises of Late-Twentieth-Century Art Theory as developed by Greenberg. He accepts every fundamental Greenberg has put forth. Realism and three-dimensional illusion are still forbidden. Flatness is still God. Steinberg simply adds: "I've found a new world that's flatter."

So that was how Pop Art came in: a new order, but the same Mother Church.

Within a few years the most famous images *of* Pop Art were Roy Lichtenstein's blowups of panels from war comics and love comics and Andy Warhol's Campbell's Soup cans and Brillo boxes. But wasn't that realism? Not at all. Quite the opposite, in fact. Alloway, the Englishman who coined the term *Pop Art,* provided the rationale: the comics, labels, and trademarks that the Pop artists liked were not representations of external

reality. They were commonplace "sign systems" of American culture. By enlarging them and putting them on canvas, the artists were converting them from messages into something that was neither message nor external image. "Pop Art is neither abstract nor realistic," said Alloway, "though it has contacts in both directions. The core of Pop Art is at neither frontier; it is, essentially, an art about signs and sign systems." That may have been a bit hard to follow, but the stamp of approval came through clearly to one and all: "It's okay! You are hereby licensed to go ahead and like these pictures. We've drained all the realism out."

Pop Art absolutely rejuvenated the New York art scene. It did for the galleries, the collectors, the gallery-goers, the art-minded press, and the artists' incomes about what the Beatles did for the music business at about the same time. It was the thaw! It was spring again! The press embraced Pop Art with priapic delight. That goddamned Abstract Expressionism had been so solemn, so grim . . . "Shards of interpenetrated sensibility make their way, tentatively, through a not always compromisable field of cobalt blue—" How could you write about the freaking stuff? Pop Art you could have fun with.

Avant-gardism, money, status, Le Chic, and even the 1960s idea of sexiness—it all buzzed around Pop Art. *The* place, without any question, was Leo Castelli's gallery at 4 East Seventy-seventh

Street. Castelli had Johns, Lichtenstein, Warhol, Robert Rauschenberg, James Rosenquist, most of the heavies. It was there that the Culture buds now hung out, beautiful little girls, with their hips cocked and the seams of their Jax slax cleaving them into hemispheres while they shot Culture pouts through their Little Egypt eyes.

God knows, the Pop artists themselves entered into the spirit of the thing. Whereas the Abstract Expressionists had so many disastrous problems double-tracking from the Boho Dance to the Consummation—whereas Pollock, Newman, Rothko, the whole push, in fact, had their own early anti-bourgeois boho ideals hovering over them forevermore like the most vengeful and vigilant superego in the history of psychology—the Pop artists double-tracked with about as much moral agony as a tape recorder. They came up with a new higher synthesis of personal conduct: to wallow in the luxuries of *le monde,* to junk it through with absolute abandon, was simply *part of the new bohemia.* Nothing to it! The artists used to hang around the apartment of Robert Scull, overlooking the Metropolitan Museum on Fifth Avenue, like children who don't know that you're supposed to go home at suppertime. They'd be there all afternoon, and Bob—Bob Scull—or Spike —Bob's wife, Ethel—he called her Spike—would go around commenting on how it was getting dark and—oh, well, how about switching on a few lights, boys—and so they'd just turn on a few lights—and by and by it would be time to eat—

and the artists would still be there, like little boys, wide-eyed and ready for goodies—and Spike would say, Well, we're going to eat now—and instead of saying, Uh, I guess I have to go home now, they'd say: Swell! Fine! Let's eat! (Where you taking us?) The only problem they had was that many of them were poor and plebeian in origin and had grown up in bohemia, and they didn't know even the rudimentary manners of life in *le monde,* but that didn't stop them for long. At first, Andy Warhol, for example, would go out to dinner and wouldn't know one end of that long lineup of silverware on the table from the other, and so he would sit there, at some five- or six-course dinner at the Burdens' or wherever, without touching a morsel, not the *crème séné-galaise* nor the lobster *cardinal* nor the veal *Val-dostana* nor the salad Grant Street nor the fresh pear halves Harry & David—until finally the lady seated to his left would say, "But, Mr. Warhol, you haven't touched a thing!"—whereupon Andy would say, "Oh, I only eat candy." Warhol learned fast, however, and he soon knew how to take whatever he wanted. The bohemian, by defi-nition, was one who did things the bourgeois didn't dare do. True enough, said Warhol, and he added an inspired refinement: nothing is more bourgeois than to be afraid to look bourgeois. True to his theory, he now goes about in button-down shirts, striped ties, and ill-cut tweed jackets, like a 1952 Holy Cross pre-med student. Warhol's ultimate liberation of the old puritanical Tenth

Street boho ego, however, came the day he put an ad in *The Village Voice* saying that he would endorse anything, anything at all, for money . . . and listing his telephone number.

Double-tracking on all sides! Double-tracking at once naïve and infinitely subtle! Underneath the very popularity of Pop Art itself, as many people knew, and nobody said, was a deliciously simple piece of double-tracking. Steinberg, Rubin, and Alloway had declared Pop Art kosher and quite okay to consume, because it was all "sign systems," not realism. But everyone else, from the collectors to the Culture buds, was *cheating!*

They were like the Mennonite who, forbidden by religious law to have a TV set in his home, props it up on the fence post outside and watches through an open window. In the middle of January he sits in his living room huddled in an overcoat and a blanket, with the window open, because *Mannix* is out on the fence. In short . . . the culturati were secretly *enjoying the realism!*—plain old bourgeois mass-culture high-school goober-squeezing whitehead-hunting can-I-pop-it-for-you-Billy realism! They looked at a Roy Lichtenstein blowup of a love-comic panel showing a young blond couple with their lips parted in the moment before a profound, tongue-probing, post-teen, American soul kiss, plus the legend "WE ROSE UP SLOWLY . . . AS IF WE DIDN'T BELONG TO THE OUTSIDE WORLD ANY LONGER . . . LIKE SWIMMERS IN A SHADOWY DREAM . . . WHO DIDN'T NEED TO BREATHE . . ." and—the hell with the *sign systems*

WE
ROSE UP
SLOWLY
...AS IF
WE DIDN'T
BELONG
TO THE
OUTSIDE
WORLD
ANY
LONGER
...LIKE
SWIMMERS
— IN A
SHADOWY
DREAM...
WHO
DIDN'T
NEED TO
BREATHE...

Private collection, Germany. Courtesy Leo Castelli Gallery

Roy Lichtenstein, "*We Rose Up Slowly . . .*" 1964.
Not realism . . . *sign systems*

—they just loved the dopey campy picture of these two vapid blond sex buds having their love-comic romance bigger than life, six feet by eight feet, in fact, up on the walls in an art gallery. Dopey . . . campy . . . Pop Art was packed with literary associations, quite in addition to the love scene or whatever on the canvas. It was, from beginning to end, an ironic, a camp, a literary-intellectual assertion of the banality, emptiness, silliness, vulgarity, et cetera of American culture, and if the artists said, as Warhol usually did, "But that's what I like about it"—that only made the irony more profound, more cool.

Collectors and other culturati also liked this side of Pop Art immensely, because it was so

familiar, so cozily antibourgeois, because once again it made them honorary congs walking along with the vanguard artists through the land of the philistines. Steinberg is the only theorist I know of, with the possible exception of Bernard Berenson, who ever went to the trouble of creating some theory specifically for the passive role of consumer of culture. Were you upset by the swiftness of change? Did it worry you that one moment Abstract Expressionism was *it*, the *final style,* and then, in the blink of an eye, Abstract Expressionism was demolished and Pop Art was *it*? It shouldn't, said Steinberg—for that was precisely where the consumer of culture could show his courage, his mettle, his soldierly bearing. For what in the world requires more courage than "to applaud the destruction of values which we still cherish"? Modern art always "projects itself into a twilight zone where no values are fixed," he said. "It is always born in anxiety." Not only that, he said, it is the very function of really valuable new Modern art to "transmit this anxiety to the spectator," so that when he looks at it, he is thrown into "a genuine existential predicament." This was basically Greenberg's line, of course— "all profoundly original art looks ugly at first"— but Steinberg made the feeling seem deeper (and a bit more refined). The clincher was Steinberg's own confession of how he had at first disliked Johns's work. He had resisted it. He had fought to cling to his old values—and then realized he was wrong. This filtered down as a kind of Turbulence

Theorem. If a work of art or a new style disturbed you, it was probably good work. If you *hated* it— it was probably *great*.

That was precisely the way Robert Scull discovered the artist Walter De Maria. Scull was walking down Madison Avenue on Saturday afternoon when he stopped in a gallery and saw some drawings that were nearly blank. They were pieces of drawing paper framed and hung, and down in one corner would be a few faint words, seemingly written by an ailing individual with a pencil so hard, a No. 8 or something, that the lead scarcely even made a line: "Water, water, water . . ." Scull hated these drawings so profoundly, he promptly called up the artist and became his patron. That brought De Maria his first recognition as a Minimal artist.

6

Up the fundamental
aperture

The Greatest Artist in the History of the World
collapses at the Automat

Minimal art was part of a comeback that abstract art began to make, even while Pop Art was still going strong. This time around, theory was more dominant than ever.

I can remember the Museum of Modern Art announcing that it was going to have an exhibition in 1965 called "The Responsive Eye," a show of paintings with special optical effects—what quickly became known as Op Art. *Quickly* is hardly the word for it. A mad rush, is more like it. Pop Art had been such a smashing success, with so many spin-offs, that it seemed like all of smart New York was primed, waiting to see what the art world would come up with next. By the time the Museum's big Op Art show opened in the fall, two out of every three women entering the glass

doors on West Fifty-third Street for the opening-night hoopla were wearing print dresses that were knock-offs of the paintings that were waiting on the walls inside. In between the time the show had been announced and the time it opened, the Seventh Avenue garment industry had cranked up and slapped the avant-garde into mass production before the Museum could even officially discover

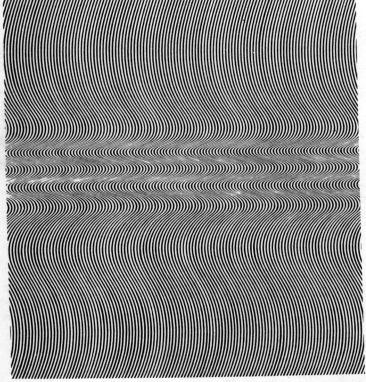

Collection, The Museum of Modern Art, New York

Bridget Riley, *Current*, 1964.
Not Op Art . . . Perceptual Abstraction

it. (They liked knocking off Bridget Riley's fields of vibrating lines best of all.)

Op, like Pop, was enjoyed for basically "literary" reasons. All of it, from Vasarely to Larry Poons, was reminiscent of the marvelous optical illusions in the syndicated newspaper feature "Ripley's 'Believe It or Not.' " But the *theory* of Op Art was something else. The Op artists never called it Op Art; they preferred Perceptual Abstraction. Their argument was: Cubism freed art from the nineteenth-century view of a painting as a window through which you saw an illusion of the real world. Earlier abstract work, such as De Stijl or Abstract Expressionism, had advanced this good work by establishing the painting as "an independent object as real as a chair or table" (to quote from "The Responsive Eye" catalogue). We Perceptual Abstractionists complete the process by turning this art object into a piece of pure perception. By creating special optical effects (but on a flat surface!) we remove it from the outside world and take it into that terra incognita "between the cornea and the brain."

Theory really started to roll now . . . toward reductionism. In this case: real art is nothing but what happens in your brain. Of course, Greenberg had started it all with his demands for purity, for flatness (ever more Flatness!), for the obliteration of distinctions such as foreground and background, figure and field, line and contour, color and pattern. Now, in the mid-1960s, Greenberg made a comeback.

He had learned a thing or two in the meantime about strategy. He no longer tried to defend Abstract Expressionism against the huge shift in taste that Pop Art represented. In fact, he offered what amounted to a piece of implied confession or, better said, self-criticism. All along, he said, there had been something old-fashioned about Abstract Expressionism, despite the many advances it brought. This old-fashioned thing was . . . its brushstrokes. Its *brushstrokes*? Yes, said Greenberg, its brushstrokes.* The characteristic Abstract Expressionist brushstroke was something very obvious, very expressive, very idiosyncratic . . . very *painterly*, like the "blurred, broken, loose definition of color and contour" you find in Baroque art. It was as obvious as a skid on the highway. He termed this stroke the "Tenth Street touch."

Lichtenstein, the Pop artist, liked this notion so much, or was so amused by it, that he did a series of *Brushstroke* paintings, each one a blowup of a single "Tenth Street touch" brushstroke, with every swirl and overloaded driblet represented— but rendered in the hard, slick commercial-illustration unpainterly style of Pop, with no brushstrokes of his own whatsoever to be seen.

Greenberg was still unbending in his opposition to Pop, but now he knew better than to just denounce it. Now he added the obligatory phrase: "—and I can show you something newer and

* This was also an implicit criticism of his old rival, Rosenberg, the original prophet of the expressive brushstroke.

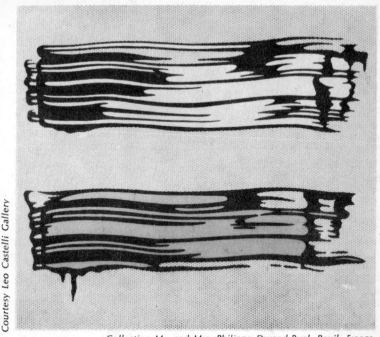

Collection Mr. and Mrs. Philippe Durand-Ruel, Reuil, France

Lichtenstein's *Yellow and Red Brushstrokes,* 1966.
Brushstrokes without a single
brushstroke showing; a flat picture of impasto
and the old-fashioned Tenth Street past

better . . . way out here.'' This, he said, was Post-
Painterly Abstraction.

Greenberg's Post-Painterly Abstraction has gone
under other names since then: Hard-Edge-Abstract
and Color Field Abstract, to name two. But all of
them can be defined by the way in which they
further the process of reduction, i.e., the way they
get rid of something—just a little bit more, if you
please! How far we've come! How religiously
we've cut away the fat! In the beginning we got

rid of nineteenth-century storybook realism. Then we got rid of representational objects. Then we got rid of the third dimension altogether and got really flat (Abstract Expressionism). Then we got rid of airiness, brushstrokes, most of the paint, and the last viruses of drawing and complicated designs (Hard Edge, Color Field, Washington School).

Collection, The Museum of Modern Art, New York

Kenneth Noland, *Turnsole*, 1961.
Noland was known as the *fastest* painter alive
(i.e., one could see his pictures faster than
anybody's else's). The explanation of why that was
important took considerably longer

Enough? Hardly, said the Minimalists, who began to come into their own about 1965. Bourgeois connotations, they argued, still hung on to Modern art like a necktie. What about all those nice "lovely" colors that the Hard Edgers and the Color Fielders used? They invited as many sentimental associations as painterly brushstrokes had. So Minimalists began using colors like Tool & Die Works red and Subway I-Beam green and Restaurant Exhaust-Fan Duct Lint gray that nobody could accuse of sentimentality. And how about all those fuzzy, swampy, misty edges that Color Fielders like Olitski and Frankenthaler went for? They invited you to linger over a painting for all its emotional "evocations," just like the worst junk of the old pre-Raphaelites. Henceforth a paint should be applied only in hard linear geometries, and you should get the whole painting at once, "fast," to use the going phrase. (No Loitering.) Kenneth Noland, formerly of Morris Louis's misty Washington School, was now considered the fastest painter in the business.

And how about the painting frame? Wasn't New York full of artists who made a big thing about treating the painting as an object—and then acted as if the frame wasn't even there? So Frank Stella turned the canvas itself into a frame and hung it on the wall with nothing in the middle. That got rid of the frames, and the era of "shaped canvases" began.

Sure, but what about this nice sweet bourgeois idea of *hanging up pictures* in the first place . . .

all in their nice orderly solid-burgher little rows?
. . . So artists like Robert Hunter and Sol Lewitt
began painting directly on the gallery walls or on
walls outside the gallery window . . . with the
faintest, most unsentimental geometric forms
imaginable . . .

Faster and faster art theory flew now, in ever-
tighter and more dazzling turns. It was dizzying,
so much so that both Greenberg and Rosenberg
were shocked—*épatés*. Greenberg accused the
Minimalists of living only for "the far-out as an
end in itself." Their work was "too much a feat
of ideation . . . something deduced instead of felt
and discovered." A little late to be saying that,
Clement! Rosenberg tried to stop them by saying
they really weren't far-out at all—they were a fake
avant-garde, a mere "DMZ vanguard," a buffer
between the *real* avant-garde (his boy de Kooning)
and the mass media. Very subtle—and absolutely
hopeless, Harold! Theory, with a head of its own
now, spun on and chewed up the two old boys
like breadsticks, like the Revolution devouring
Robespierre and Danton—faster and faster—in
ever-tighter and more dazzling turns—let's see,
we just got rid of the little rows of *hung pictures*,
not to mention a couple of superannuated critics,
and we've gotten rid of illusion, representational
objects, the third dimension, pigment (or most
of it), brushstrokes, and now frames and canvas—
but what about the wall itself? What about the

Tampa (1964) by Frank Stella,
who stood staunchly by the Word:
fast, hard, flat, and unevocative,
with paradise aforethought

very idea of a work of art as something "on a wall" at all? How very pre-Modern! How can you treat the wall as something separate from the gallery, the room, the space in which it exists?

And so artists like Carl André, Robert Morris, Ronald Bladen, and Michael Steiner did huge geo-

metric (unsentimental, uncolorful, fast) sculptures designed to divide up the entire gallery into spaces, to make the very building part of the sculpture in some way. No more "hanging" an exhibition; these were "installations."

But what about the very idea of the gallery or museum? What about the very notion of a nice sedate sanctum where one—meaning a person of the proper gentility—comes to gaze upon Art and the Artist with a glaze of respect and silence over his mug? Wasn't there something impossibly retrograde about the whole thing? So began Earth Art, such as Michael Heizer's excavations in the dry lakes of the Mojave Desert and Robert Smithson's *Spiral Jetty* in the Great Salt Lake.

By now it was the late 1960s, and the New Left was in high gear, and artists and theorists began to hail Earth Art and the like as a blow against "the Uptown Museum-Gallery Complex," after the "military-industrial complex" out in the world beyond. If the capitalists, the paternalists of the art world, can't get their precious art objects into their drawing rooms or even into their biggest museums, they've *had it*. A few defiant notes like this, plus the signing of a few dozen manifestos against war and injustice—that was about as far as New York artists went into Left politics in the 1960s. With everyone now caught up in the spin of Theory, at such a furious velocity, the notion of putting on the brakes and doing that 1930s number again, cranking out some good old Social Realism propaganda, was too impossible to

even think about. No, a few raspberries for the "museum-gallery complex" ... and let's get back to business.

Back to business ... which in the late 1960s was the monomaniacal task of *reduction*. What about the idea of a permanent work of art at all, or even a visible one? Wasn't that the most basic of all assumptions of the Old Order—that art was eternal and composed of objects that could be passed from generation to generation, like Columbus's bones? Out of that objection came Conceptual Art.

The Conceptualists liked to propound the following question: Suppose the greatest artist in the history of the world, impoverished and unknown at the time, had been sitting at a table in the old Automat at Union Square, cadging some free water and hoping to cop a leftover crust of toasted corn muffin or a few abandoned translucent chartreuse waxed beans or some other item of that amazing range of Yellow Food the Automat went in for—and suddenly he got the inspiration for the greatest work of art in the history of the world. Possessing not even so much as a pencil or a burnt match, he dipped his forefinger into the glass of water and began recording this greatest of all inspirations, this high point in the history of man as a sentient being, on a paper napkin, with New York tap water as his paint. In a matter of seconds, of course, the water had diffused through the paper and the grand design

vanished, whereupon the greatest artist in the history of the world slumped to the table and died of a broken heart, and the manager came over, and he thought that here was nothing more than a dead wino with a wet napkin. Now, the question is: Would that have been the greatest work of art in the history of the world or not? The Conceptualists would answer: Of course, it was. It's not permanence and materials, all that Winsor & Newton paint and other crap, that are at the heart of art, but two things only: Genius and the *process* of creation! Later they decided that Genius might as well take a walk, too.

Conceptual Art divided into two sorts: things you could see, but not for long (like the Great Man's water picture), and things you couldn't see at all. From the first category came Peter Hutchinson's *Arc*. He filled some plastic bags with gas and pieces of rotten calabash or something of the sort, which was supposed to create more gas, tied the bags to a rope, put weights on either end of the rope, threw the whole business into the ocean, where the weights hit the bottom and the gas bags rose up, lifting the rope in an arc. An underwater photographer took pictures of the installation and then came back periodically to record the decay of the garbage and the eventual bursting of the bags and collapse of the arc—the disappearance of the art object, in short. Genius and process—process and genius! The photographs and quite a few lines of off-scientific prose provided the documentation, as it is known in Con-

ceptual Art—which Hutchinson thereupon sold to the Museum of Modern Art for . . . well, today Museum officials prefer not to talk about how much they paid for *Arc*. One assumes that they paid no more than was necessary to remain buoyant in the turbulent intellectual waters of the late 1960s.

As for the second category—one of the great outposts of invisible Conceptual Art was the Richmond Art Center in Richmond, California, when Tom Marioni was its director. It was there that I came upon the fabulous *Beautiful Toast Dream,* by a woman whose name I can't remember. The documentation, which was typed, described how she woke up in the dark at about four in the morning and had a sudden craving for a piece of toast. The craving was so strong, in fact, that she could see it, a crust of Wonder Bread done light brown, and she could already visualize herself taking the crust out of the toaster and spreading Nucoa margarine on it with a serrated knife with a wooden handle, one of those slender numbers with little teeth on the blade that are good for cutting tomatoes or grapefruit, and she can see herself putting the Nucoa on the toast and then sprinkling some white sugar, the usual kind, on top of that and then shaking some cinnamon on it and then spreading it all on with the serrated knife until the heat of the toast begins to melt the margarine and the teeth of the knife begin to dig little furrows in the bread and the molten margarine begins to build up ahead of each tooth

and then runs off between the teeth and into the furrows—but not by itself!—no, the margarine and little *ripped papillae of bread* run together carrying with them on the surface of the tide granules of sugar that absorb the molten margarine and turn yellow and disappear in this viscous flood of heat, steel, and fragmented bread papillae while the cinnamon maintains its spreckled identity except when bunching up on the oleaginous surface of the flood like a stain and the crest keeps building but becomes neither fluid nor solid but more of a blob existing only as a kinetic wobble swelling into one final macerated mulled mass reflected in the stainless steel face of the blade as a tawny cresting wave bound by an unbearable surface tension until—all at once!—it is ripped, raked, ruptured by the blade and suddenly leaks as if through deflation between the teeth and into the lengthening furrows behind the blade sinking lamely into a harrowed and utterly swamped tan bread delta and she knows it is time to bite off a corner of the crust with yellow Nucoa-soaked sugar grains scraping the ridges of her teeth and caking in the corners of her mouth —but there were *no crusts to be found*—and she *could have no toast*—and she had to have a swig of Diet-Rite Cola instead—and, well, I mean I can only *hint* at the tension, the velocity, the suspense, the meth-like electron-microscopic eye for detail and *le mot juste* that this woman's documentation had—it went on and on; a certain Frenchman would have given up the silence of

his cork-lined studio to have had *one-tenth* of this woman's perception of the minutiae of existence or, in this case, nonexistence, *one-twentieth* of her patience, *one-hundredth* of her perseverance to stay with the description until the job is truly done—in short, I was in the presence of . . . *superb post-Proustian literature!*

With works such as that, late twentieth-century Modern art was about to fulfill its destiny, which was: to become nothing less than Literature pure and simple. But the destined terminus had not yet been reached. After all, the artist of *Beautiful Toast Dream* had first gone through a visual experience, even if only imagined. After all, what about the whole business of "the visual imagination"? Came the refrain: How very pre-Modern.

David R. Smith (not the sculptor) tried to get rid of this, one of the last pieces of the old bourgeois baggage, through a piece called "Vacant":

VA CA NT

TN AC AV

Collection, Museum of Conceptual Art

—which was calculated to make the viewer concentrate on the utter emptiness between the letters. But he failed. He had still committed an act of visual imagination, even though in the service of invisibility, emptiness, nihilism. He had not gotten rid of the fundamental, the primary, the indigenous, the intrinsic, the built-in, the unitary and atomic impurity of the whole enterprise: namely, the artistic ego itself.

So it was that in April of 1970 an artist named Lawrence Weiner typed up a work of art that appeared in *Arts Magazine*—as a work of art— with no visual experience before or after whatsoever, and to wit:

1. The artist may construct the piece
2. The piece may be fabricated
3. The piece need not be built

Each being equal and consistent with the intent of the artist the decision as to condition rests with the receiver upon the occasion of receivership.

With permission, Arts Magazine

And there, at last, it was! No more realism, no more representational objects, no more lines, colors, forms, and contours, no more pigments, no more brushstrokes, no more evocations, no more frames, walls, galleries, museums, no more gnawing at the tortured face of the god Flatness, no more audience required, just a "receiver" that may or may not be a person or may or may not be there at all, no more ego projected, just "the

artist," in the third person, who may be anyone or no one at all, for nothing is demanded of him, nothing at all, not even existence, for that got lost in the subjunctive mode—and in that moment of absolutely dispassionate abdication, of insouciant withering away, Art made its final flight, climbed higher and higher in an ever-decreasing tighter-turning spiral until, with one last erg of freedom, one last dendritic synapse, it disappeared up its own fundamental aperture . . . and came out the other side as Art Theory! . . . Art Theory pure and simple, words on a page, literature undefiled by vision, flat, flatter, Flattest, a vision invisible, even ineffable, as ineffable as the Angels and the Universal Souls.

Epilogue

For about six years now, realistic painters of all sorts, real nineteenth-century types included, with 3-D and all the other old forbidden sweets, have been creeping out of their *Stalags*, crawl spaces, DP camps, deserter communes, and other places of exile, other Canadas of the soul—and have begun bravely exhibiting. They have been emboldened by what has looked to them, as one might imagine, as the modern art of Art Theory gone berserk.

The realist school that is attracting the most attention is an offshoot of Pop Art known as Photo-Realism. The Photo-Realists, such as Robert Bechtle and Richard Estes, take color photos of Pop-like scenes and objects—cars, trailers, storefronts, parking lots, motorcycle engines—then

Richard Estes, *Bus Reflection*, 1972.
Perhaps the leading Photo-Realist, or at any rate
the most richly denounced; if the power to

cause cortical blowouts in critics is
any recommendation, he can't miss

reproduce them precisely, in paint, on canvas, usually on a large scale, often by projecting them onto the canvas with a slide projector and then going to work with the paint. One of the things they manage to accomplish in this way, beyond the slightest doubt, is to drive orthodox critics bananas.

Such denunciations! "Return to philistinism" . . . "triumph of mediocrity" . . . "a visual soap opera" . . . "The kind of academic realism Estes practices might well have won him a plaque from the National Academy of Design in 1890" . . . "incredibly dead paintings" . . . "rat-trap compositional formulas" . . . "its subject matter has been taken out of its social context and neutered" . . . "it subjects art itself to ignominy" . . . all quotes taken from reviews of Estes's show in New York last year . . . and a still more fascinating note is struck: "This is the moment of the triumph of mediocrity; the views of the silent majority prevail in the galleries as at the polls."

Marvelous. We are suddenly thrust back fifty years into the mental atmosphere of Royal Cortissoz himself, who saw an insidious connection between the alien hordes from Southern Europe and the alien wave of "Ellis Island art." Only the carrier of the evil virus has changed: then, the subversive immigrant; today, the *ne kulturny* native of the heartland.

Photo-Realism, indeed! One can almost hear Clement Greenberg mumbling in his sleep: "All profoundly original art looks ugly at first . . . but

there is ugly and there is *ugly!*" . . . Leo Steinberg awakes with a start in the dark of night: "Applaud the destruction of values we still cherish! But surely—not *this!*" And Harold Rosenberg has a dream in which the chairman of the Museum board of directors says: "Modernism is finished! Call the cops!"

Somehow a style to which they have given no support at all ("lacks a persuasive theory") is *selling*. "The New York galleries fairly groan at the moment under the weight of one sort of realism or another" . . . "the incredible prices" . . . Estes is reported to be selling at $80,000 a crack . . . Bechtle for £20,000 at auction in London . . . Can this sort of madness really continue "in an intellectual void"?

Have the collectors and artists themselves abandoned the very flower of twentieth-century art: i.e., Art Theory? Not yet. The Photo-Realists assure the collectors that everything is okay, all is kosher. They swear: we're not painting real scenes but, rather, camera images ("not realism, *photo systems*"). What is more, we don't show you a brushstroke in an acre of it. We're painting only scenes of midday, in bland sunlight—so as not to be "evocative." We've got all-over "evenness" such as you wouldn't believe—we put as much paint on that postcard sky as on that Airstream Silver Bullet trailer in the middle. And so on, through the checklist of Late Modernism. The Photo-Realists are backsliders, yes; but not true heretics.

In all of Cultureburg, in fact, there are still no heretics of any importance, no one attacking Late Modernism in its very foundation—not even at this late hour when Modern art has reached the vanishing point and our old standby, Hilton Kramer, lets slip the admission: Frankly, these days, without a theory to go with it, I can't *see* a painting.

"Lets slip," as I say. We now know, of course, that his words describe the actual state of affairs for *tout le monde* in Cultureburg; but it is not the sort of thing that one states openly. Any orthodox critic, such as Kramer, is bound to defend the idea that a work of art can speak for itself. Thus in December 1974 he attacked the curators of the Metropolitan Museum's exhibition "The Impressionist Epoch" for putting big historical notes up on the wall beside the great masterworks of the Impressionists. But why? What an opportunity he missed! If only he could have drawn upon the wisdom of his unconscious! Have the courage of your secret heart, Hilton! Tell them they should have made the copy blocks *bigger*!—and reduced all those Manets, Monets, and Renoirs to the size of wildlife stamps!

Twenty-five years from now, that will not seem like such a facetious idea. I am willing (now that so much has been revealed!) to predict that in the year 2000, when the Metropolitan or the Museum of Modern Art puts on the great retrospective exhibition of American Art 1945–75, the three

artists who will be featured, the three seminal
figures of the era, will be not Pollock, de Kooning,
and Johns—but Greenberg, Rosenberg, and Stein-
berg. Up on the walls will be huge copy blocks,
eight and a half by eleven feet each, presenting
the protean passages of the period . . . a little
"fuliginous flatness" here . . . a little "action paint-
ing" there . . . and some of that "all great art is
about art" just beyond. Beside them will be small
reproductions of the work of leading illustrators
of the Word from that period, such as Johns,
Louis, Noland, Stella, and Olitski. (Pollock and
de Kooning will have a somewhat higher status,
although by no means a major one, because of
the more symbiotic relationship they were for-
tunate enough to enjoy with the great Artists of
the Word.)

Every art student will marvel over the fact that
a whole generation of artists devoted their careers
to getting the Word (and to internalizing it) and
to the extraordinary task of divesting themselves
of whatever there was in their imagination and
technical ability that did not fit the Word. They
will listen to art historians say, with the sort of
smile now reserved for the study of Phrygian
astrology: "That's how it was then!"—as they de-
scribe how, on the one hand, the scientists of the
mid-twentieth century proceeded by building
upon the discoveries of their predecessors and
thereby lit up the sky . . . while the artists pro-
ceeded by averting their eyes from whatever their
predecessors, from da Vinci on, had discovered,

shrinking from it, terrified, or disintegrating it with the universal solvent of the Word. The more industrious scholars will derive considerable pleasure from describing how the art-history professors and journalists of the period 1945–75, along with so many students, intellectuals, and art tourists of every sort, actually struggled to *see* the paintings directly, in the old pre-World War II way, like Plato's cave dwellers watching the shadows, without knowing what had projected them, which was the Word.

What happy hours await them all! With what sniggers, laughter, and good-humored amazement they will look back upon the era of the Painted Word!

The Pump House Gang
Tom Wolfe

'The whole book is savage, satiric, bawdy, funny
and wild'
BOSTON GLOBE

'One night, in the very middle of the period when I was
writing these stories, I put on my electric-blue suit – it is
truly electric-blue – and took part in a symposium at
Princeton with Günter Grass and Allen Ginsberg . . .
"What are you talking about?" I said.
"We're in the middle of a . . . Happiness Explosion! . . .
if we want to be serious, let us discuss the real
apocalyptic future and things truly scary: ego extension,
the politics of pleasure . . . the pharmacology of
Overjoy . . . " '

'Wolfe can make you taste the great glad-bagged club
sandwich that is America today'
NEWSWEEK

'Tom Wolfe is the kind of writer who grabs your mind and
runs with it, jumping, soaring, racing through the rapids,
round the whirlpool and out the other side, tumbling
joyful, roaring – sane'
LOS ANGELES FREE PRESS

0552 99371 9

BLACK SWAN

The Electric Kool-Aid Acid Test
Tom Wolfe

'A day-glo book, illiminating, merry, surreal!'
WASHINGTON POST

'I looked around and people's faces were distorted . . .
lights were flashing everywhere . . . the screen at the end
of the room had three or four different films on it at once,
and the strobe light was flashing faster than it had been
. . . the band was playing but I couldn't hear the music
. . . people were dancing . . . someone came up to me
and I shut my eyes and with a machine he projected
images on the back of my eye-lids . . . I sought out a
person I trusted and he laughed and told me that the
Kool-Aid had been spiked and that I was just beginning
my first LSD experience . . . '

'Not simply the best book on the gippies, it is the essential
book . . . The pushing, ballooning heart of the matter . . .
Vibrating dazzle!'
NEW YORK TIMES

'Tom Wolfe is a groove and a gas. Everyone should send
him money and other fine things. Hats off to Tom Wolfe!'
TERRY SOUTHERN

0552 99366 2

BLACK SWAN

The Right Stuff
Tom Wolfe

'One of the most romantic and thrilling books ever written about men who put themselves in peril'
BOSTON GLOBE

'What is it, I wondered, that makes a man willing to sit up on top of an enormous Roman candle, such as a Redstone, Atlas, Titan, or Saturn rocket, and wait for someone to light the fuse? I decided on the simplest approach possible. I would ask a few astronauts and find out.'

'The Right Stuff is Wolfe's best book.'
SUNDAY TIMES

'The Right Stuff is an exhilarating flight into fear, love, beauty and fiery death. Magnificent.'
PEOPLE MAGAZINE

'Absolutely first class. Impossible as some of Tom's tales seem. I know he's telling it like it was'
FORMER ASTRONAUT MICHAEL COLLINS

0552 99367 0

BLACK SWAN

A SELECTED LIST OF FINE NOVELS
AVAILABLE FROM BLACK SWAN

THE PRICES SHOWN BELOW WERE CORRECT AT THE TIME OF GOING TO PRESS. HOWEVER TRANSWORLD PUBLISHERS RESERVE THE RIGHT TO SHOW NEW RETAIL PRICES ON COVERS WHICH MAY DIFFER FROM THOSE PRE-VIOUSLY ADVERTISED IN THE TEXT OR ELSEWHERE.

☐	99198 8	**THE HOUSE OF THE SPIRITS**	*Isabel Allende*	£4.99
☐	99313 1	**IF LOVE AND SHADOWS**	*Isabel Allende*	£3.95
☐	99160 0	**FIRE FROM WITHIN**	*Carlos Castenda*	£3.95
☐	99169 4	**GOD KNOWS**	*Joseph Heller*	£3.95
☐	99195 3	**CATCH-22**	*Joseph Heller*	£4.95
☐	99208 9	**THE 158lb MARRIAGE**	*John Irving*	£3.95
☐	99204 6	**THE CIDER HOUSE RULES**	*John Irving*	£3.95
☐	99209 7	**THE HOTEL NEW HAMPSHIRE**	*John Irving*	£4.95
☐	99206 2	**SETTING FREE THE BEARS**	*John Irving*	£4.95
☐	99207 0	**THE WATER METHOD MAN**	*John Irving*	£4.95
☐	99205 4	**THE WORLD ACCORDING TO GARP**	*John Irving*	£4.95
☐	99323 9	**DREAMS OF LEAVING**	*Rupert Thomson*	£4.95
☐	99367 0	**THE RIGHT STUFF**	*Tom Wolfe*	£4.99
☐	99366 2	**THE ELECTRIC KOOL-AID ACID TEST**	*Tom Wolfe*	£4.99
☐	99370 0	**THE PAINTED WORD**	*Tom Wolfe*	£3.55

All Corgi/Bantam books are available at your bookshops or newsagents, or can be ordered from the following address:

Corgi/Bantam Books,
Cash Sales Department,
P.O. Box 11, Falmouth, Cornwall TR10 9EN

Please send a cheque or postal order, (no currency) and allow 60p for postage and packing for the first book plus 25p for the second book and 15p for each additional book ordered up to a maximum charge of £1.90 in UK.

B.F.P.O. customers please allow 60p for the first book, 25p for the second book plus 15p per copy for the next 7 books, thereafter 9p per book.

Overseas customers, including Eire, please allow £1.25 for postage and packing for the first book, 75p for the second, and 28p for each subsequent title ordered.